Creating
IMPRESSIONIST
LANDSCAPES
in Oil

BY COLLEY WHISSON

international
artist

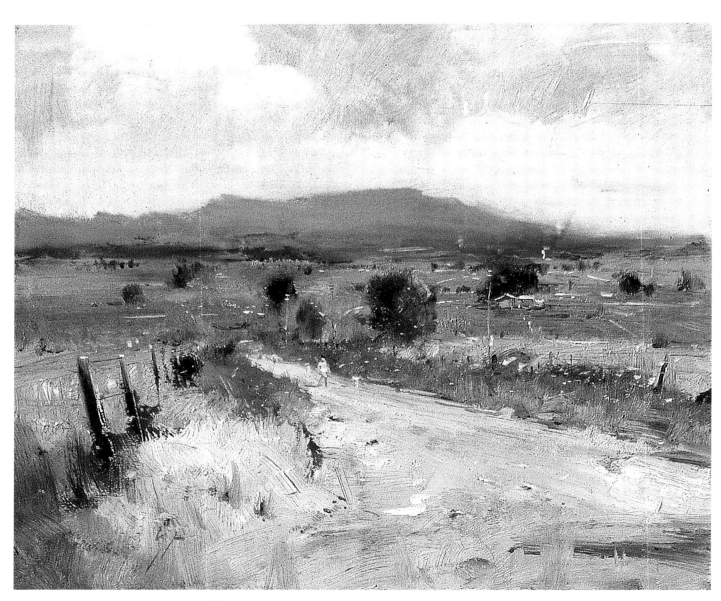

"The Road to the Grampians", 10 x 12" (25 x 31cm)

Creating
IMPRESSIONIST
LANDSCAPES
in Oil

BY COLLEY WHISSON

international
artist

international
artist

International Artist Publishing, Inc
2775 Old Highway 40
P.O. Box 1450
Verdi, Nevada 89439
Website: www.international-artist.com

Edited by Terri Dodd
Designed by Vincent Miller
Photography and illustrations by Colley Whisson
Typeset by Ilse Holloway and Cara Miller

　　　　　Library of Congress Cataloging-in-Publication Data
Whisson, Colley, 1966–
　　Creating impressionist landscape in oil : how to master impressionism step by step / by Colley Whisson.
　　　p. cm.
　　ISBN 1-929834-10-1
　　1. Landscape painting— Technique.
　　2. Impressionism (Art) I. Title.
　　ND1342.W67 2001
　　751.45'436—dc21
　　　　　　　　　　　　　　2001024512

Printed in Hong Kong
First printed in hardcover 2001
05 04 03 02 01　5 4 3 2 1

Distributed to the trade and art markets in North America by:
North Light Books,
an imprint of F&W Publications, Inc
1507 Dana Avenue
Cincinnati, OH 45207
(800) 289-0963

Acknowledgment

I wish to thank my wife Stephanie for all her support and encouragement, and my sons Alex and Travis. I would like to thank my family and friends for their continued encouragement. I would like to give special thanks to my Publisher, Vincent Miller, my Editor, Terri Dodd, and International Artist Publishing for the many opportunities I have been given.

　　I wish to thank the collectors of my work, to whom I owe a great deal, and all the artists who have helped and encouraged me with my progress.

　　I am very grateful to my art galleries: Pages' Fine Art Galleries, Red Hill Art Gallery and the Kew Art Gallery in Melbourne; McGrath Art Gallery in North Sydney and David Sumner Gallery in Toorak Gardens, Adelaide, South Australia.

Foreword

During the mid-1990s, I became aware of an up-and-coming young artist, Colley Whisson, whose work often hung beside mine at The Beachside Art Gallery in Noosa, Queensland.

When I first saw Colley's paintings, I was surprised to learn that the artist was a young man, still in his twenties, because I felt his work showed maturity well beyond his years. He is disciplined and traditional in his attitude towards the training of a painter, and he strictly adheres to the principle that all aspects of art can only be mastered through study and application.

In talking to Colley, while preparing for our joint exhibition in 1996, I realised there were many parallels in our training and our approach to painting. We both began painting professionally at age 20. We both prefer painting in oils and we both enjoy painting out of doors.

Both Colley and I believe it is essential that artists learn to draw before attempting to paint. Colley regards regular drawing as an essential part of his ongoing development as an artist. He studied figure drawing at the Queensland College of Art and studied portraiture at the Brisbane Institute of Art.

Another belief we share is that if you are going to succeed in art, you must be introduced to still life before turning to landscape painting. It is an old school of thought, but a very good one, and all the Masters adhered to it.

I was very impressed to see that Colley still includes still life paintings in his exhibitions. They are his favorite distraction from landscape painting. Still life requires skill and accuracy in tonal changes and color mixing. To make sure that his colors are clean and precise, Colley uses a palette knife to clean his mixing area before proceeding to the next mixture.

Another aspect we have in common is that we both regard our paintings as tonal exercises in color, and our art comprises many tones only made visible through the half closed eyes. We are both great exponents of being generous with paint and using plenty of brushes.

As a young lad, I spent many hours studying the paintings at the South Australian Art Gallery, where I first encountered and became influenced by the Heidelberg School of painters who worked on site. While influenced by many of those painters, particularly Arthur Streeton, Tom Roberts and, to a lesser degree, Frederick McCubbin, I prefer to paint the forest floor rather than the more traditional landscapes chosen by Colley.

While clearly acknowledging his admiration for the work

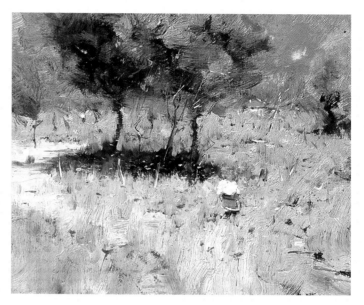

"Returning Home", by Colley Whisson

of Arthur Streeton, Colley's paintings reveal his individual instinct for interpreting color and light. He lives by the rule "quality brushstrokes, not quantity".

Colley believes his vision must exceed his ability, because then he will always have something to aim for, something that will lift his game. Like me, he still believes his best painting is yet to come.

Colley is a young man determined to become an important Australian artist of the twenty-first century. I am proud he has chosen me as his mentor and I consider it an honor to write the foreword to his first book.

— Hal Barton

Hal Barton is one of Australia's most respected and well-loved painters. He has won more than 30 major prizes including four Camberwell Rotary Art Prize awards, three First Prizes in 1990, 1996, 1998 and the Gold Medal for the Best Oil Painting in 1999. His many other awards are too numerous to mention. His work has been featured in Australian Artist *magazine and* International Artist *magazine. Now in his 70s, Hal lives and paints on the Sunshine Coast in Queensland. In December 1996 Hal invited Colley Whisson to share an exhibition with him at Pages' Fine Art Galleries.*

Contents

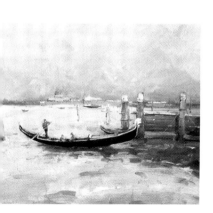

PART 3 *Demonstrations*

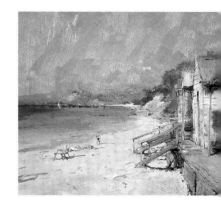

Introduction

You can be an Impressionist too

LET'S BORROW SOME IDEAS FROM THE IMPRESSIONISTS.

Of all the painting approaches, it seems the style most dear to the hearts of aspiring artists is Impressionism. It's the way most people tell me they want to paint.

The term is most frequently applied to paintings where the artist aims to capture a visual impression rather than paint a factual report. Impressionism is about the play of light rather than about the details, therefore the work has the characteristics of a sketch rather than a finished painting. Impressionism is about suggesting form through the color of the tone rather than through classic modeling. Monet called it, "a spontaneous work, rather than a calculated one".

In this book, we borrow from the Impressionist approach to painting.

First, we'll look at what sets Impressionism apart — you'll see a breakdown of the tell-tale signs in our anatomy of an impressionistic painting. Then I will point out some traps. For instance, when people set out to paint an impressionistic landscape they have a tendency to try to find a classic, knock-out scene before they can begin. Sometimes they can't find a suitable scene, and they end up not painting at all. But what makes a classic, knock-out scene, is how you treat it. I would like to say that the Impressionists painted scenes of everyday life. I will show you how a small amount of alteration can turn ordinary scenes into marvellous works in the impressionistic style.

Another important consideration in a painting that borrows from the Impressionists is brushwork. I will show you that the key to an interesting impressionistic painting is in how you use your brush to describe the forms. Varying your brushstrokes also gives you the opportunity to solve many painting problems.

One of the greatest secrets I will be sharing in this book has to do with developing your drawing skills. While I know many people believe Impressionist painting is about daubing away at the canvas with beautiful color, DRAWING is the ingredient that will make it all work. In addition, of all the ways to learn tone and color, working with the tones in a pencil

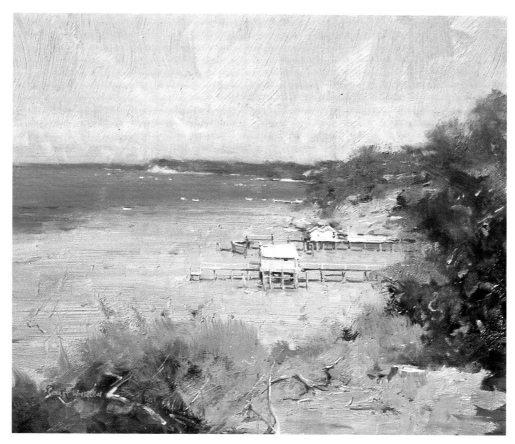

"Warmed by the Sun", 11 x 13" (28 x 33cm)

drawing is the best. I believe that drawing, and an understanding of tonal values, gives you the fundamental building blocks of an impressionistic work.

The next avenue we will explore has to do with design and composition. You will learn how to work most of the painting in a loose impressionistic style and then develop the focal area. I'll show you how to emphasize the focal area and why you should take every object into consideration when beginning a painting. I'll show how directional lines and secondary lines work to enhance the composition, and many other ways you can use to control the viewer's eyepath.

Adding a figure or another element to a painting can bring it to life and make all the difference to a scene that would otherwise be fairly ho-hum. A figure can change the mood completely — and I will show you how it's done.

Another device that brings a painting alive is the way you use color. But this will only work if the colors and tones harmonize. I'll show you how to use a range of warm and cool tones to create a selection of marvellous impressionistic scenes and show you how to avoid the pitfalls that lead to monotonous, flat, cold and insipid paintings.

While we explore all these practical considerations we will continually reach for the soul of the painting — we will ask how we can idealize a subiect so that it becomes something exceptional. We look at vision and pictorial thought, atmosphere, texture, mystery and mood and how shadow plays its part in the scheme of things.

I am sure my series of step-by-step demonstrations, examples and diagrams will help you improve your own ability as you borrow from the captivating techniques of the Impressionists.

I invite you to embark on a fascinating journey with me.

— *Colley Whisson*

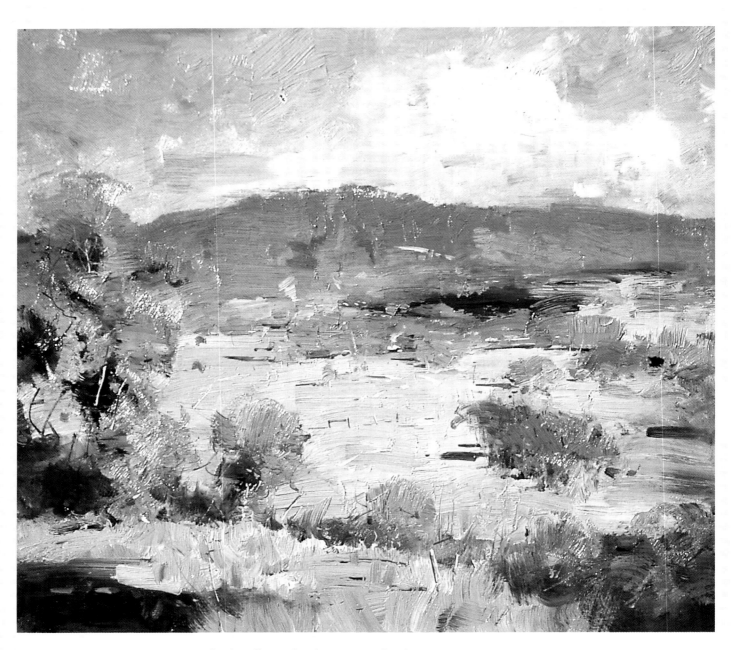

"Samford Valley Splendor, Queensland", 15 x 17" (38 x 43cm)

Defining an Impressionist Landscape

What is an Impressionist painting?

LET'S LOOK AT HOW AND WHY THIS EXCITING MOVEMENT GOT ITS NAME — AND HOW WE CAN LEARN FROM THE IMPRESSIONISTS' WAY WITH LIGHT, COLOR AND TONE.

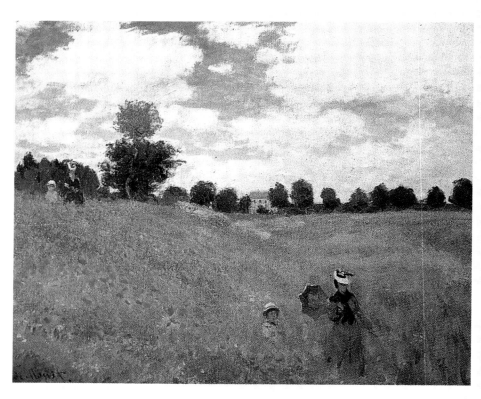

"Wild Poppies, Near Argenteuil", 1873 by Claude Monet
No longer chained to the studio, or bound to classsical notions of subject matter, the Impressionists painted everyday scenes on-site.

Someone once called Impressionism "a moment in time" — it was certainly the major movement in 19th century art. The name springs from a painting called "Impression: Sunrise" exhibited in 1874 by Frenchman, Claude Monet, and the sidebar opposite tells you more about how it all began. Almost immediately, the word Impressionism was used to describe the entire group of Parisian artists who exhibited as the Society of Painters, Etchers and Engravers.

Well known Impressionists include Renoir, Sisley, Pissarro, Cassatt, Morisot and Manet. In America the names of William Merrit Chase, Childe Hassam and John Henry Twachtman spring to mind. In my own country, Australia, Sir Arthur Streeton, Tom Roberts and Frederick McCubbin were revered for their "impressions" of the landscape.

In this book we will look at the ideas and techniques of the Impressionists and borrow from them to create our own light-filled landscapes where the tone of the color is paramount.

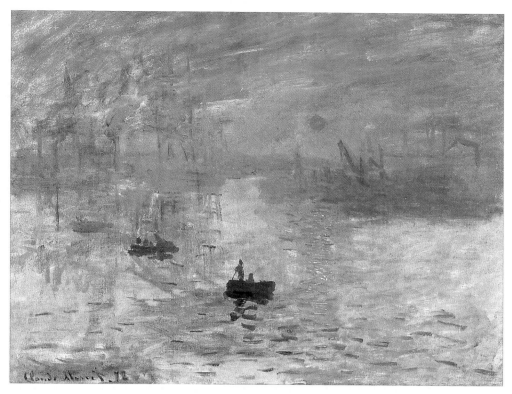

"Impression: Sunrise", 1872 by Claude Monet
The painting that gave an art movement its name.

What's in a name?

The Impressionists did not choose their name, it was pinned on them as an insult by a critic after he saw Monet's painting "Impression: Sunrise" at an exhibition in 1874. Monet's painting formed part of an exhibition of works by a new group of artists that included Renoir, Sisley, Pissarro and Morisot, with Manet as their mentor. Closely associated were Degas and Cassatt. Cézanne also exhibited with them.

The first exhibition caused an uproar. Visitors mocked the exhibits, saying the artists had fired paint at their canvases from a pistol. Others dismissed the works as "wallpaper", and the brushmarks as "black tongue-lickings".

In fact, the battle lines between traditional and more progressive artists had been drawn up a year earlier when the jury of the official Paris Salon had rejected two-thirds of the 5,000 paintings submitted for exhibition. That's when the group decided to form their own exhibition and where the name "Impressionism" was born.

Art was indeed undergoing a revolution — a break away from the centuries of classical art hanging in museums. The craft-based master/apprentice system of the Old Masters had been replaced by strict academic teaching that many artists experienced as constricting. Even the methods of painting were changing because paints once mixed by apprentices, were being manufactured commercially. In many ways the old artisan approach to the procedure of painting and the associated knowledge, was disappearing.

Another major impact on the art of the day was the invention of photography, which was reproducing what had previously been achieved on canvas and paper. Photography showed artists there were new ways to depict the visible world

As well, 18th century Japanese artists, who had bravely broken with their own 1000-year-old traditions, were depicting scenes of ordinary life in their woodcuts. These boldly colored prints defied all the rules of composition that underpinned

Academic art and offered western artists a totally new vision of what art could be.

The main thing was that the Impressionists wanted to paint from nature, out in the glorious open air. They wanted to capture the initial, fleeting impression of a scene, rather than slavishly paint every detail. They abandoned the technique of gradual shading of muted tones from light to dark in favor of contrasts and colored shadows. Furthermore, any subject, no matter how humble, was a potential artwork — they turned their backs on the classic subject as laid down by Academic tradition.

The Impressionists had to endure being called lunatics and heretics and their work was insulted as "slapdash". Although they suffered hostility, and many experienced financial hardship, they remained true to their ideals. While some Impressionists were recognized in their lifetime, others died without realizing they were leaving a precious legacy for the artists to come.

When you go out to paint, try to forget what objects you have before you; a tree, a house, a field or whatever. Merely think here is a little square of blue, here an oblong of pink, here a streak of yellow, and paint it just as it looks to you, the exact colour and shape, until it gives you your own naïve impression of the scene before you.

— Claude Monet

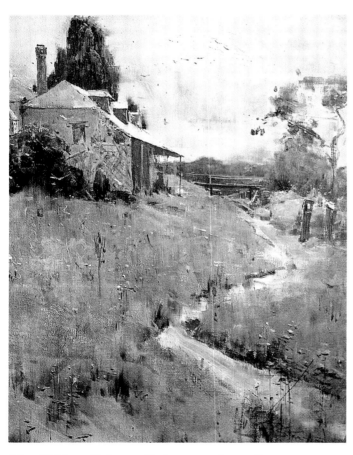

"The Old Inn, Richmond", by great Australian Impressionist, Sir Arthur Streeton (1867-1943)

"The Harvest", 1876, by Camille Pissarro

"Morning on the Breakwater, Shinnecock, Long Island", 1897, by William Merritt Chase

"Mystic Morning", by the author

"Charm of Country Victoria", by the author,
11 x 13" (28 x 33cm)

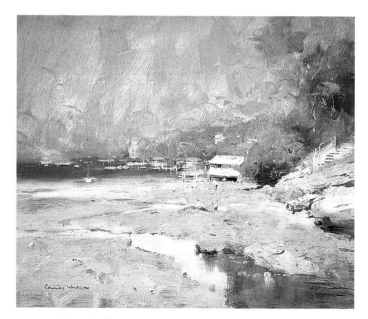

"Low Tide, Shell Cove", by the author

Everything painted directly and on the spot has a strength, vigour and vivacity of touch that can never be attained in the studio; three brushstrokes from nature are worth more than two days studio work at the easel.

— Eugène Boudin

The anatomy of an Impressionist painting

hese are the techniques the Impressionists used to paint their quick, on-the-spot impressions of changing light and atmosphere.

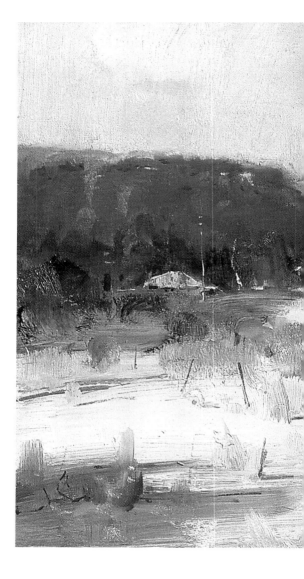

Light comes first and foremost.

Colors are undermixed, producing raw, vibrant effects.

Warm and cool color juxtapositions are used to evoke form instead of the tonal modeling method.

There is uniform loading of paint surface — even in the shadows.

Introducing color into the shadows is important.

Strongly descriptive brushstrokes catch the character of the forms.

A sketchy execution is essential to the final appearance of immediacy.

There are passages of long, unbroken strokes, short, horizontal daubs, and abrupt jabs.

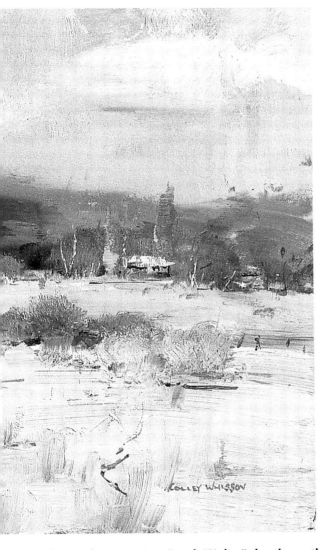

"Sunlit Landscape, New South Wales", by the author

Impressionists put down the colors they saw, not the colors they knew.

Large strokes for foregrounds and small, almost imperceptible touches in the distance give the appearance of depth.

Impressionistic work uses reflected color.

Large planes of color with little or no detail means there is nothing to detract from the broad composition.

Color is not premeditated.

Subjects are open, airy scenes.

Light coming from behind the artist, and midday light, with its harsh, bleaching effects, are the preferred conditions.

Seeing like an impressionist

WHAT DID THE
IMPRESSIONISTS SEE,
AND WHAT CAN WE
LEARN FROM THEIR WAY
OF SEEING?

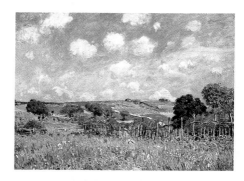

"Meadow" by Alfred Sisley (1875)

When you think of Impressionism it's easy to imagine a bygone age of leisurely Parisian summers. Of artists and their easels spread out along the banks of the Seine making their swift, on-the-spot impressions of the changing light and atmosphere.

But what did they see? The Impressionists avoided the Academic school method of painting deep, dark forest settings painted in the studio. They preferred to paint open airy scenes, broad boulevards, rivers and seascapes. They painted scenes that were full of light, with minimal shadows. In particular, they liked the light to shine on the scene from behind them, casting shadows out of sight, behind the subjects.

The Impressionists also preferred Europe's characteristic overcast skies because it produced an even diffusion of light, although the midday sun, with its hard, bleaching effects, was another favorite condition. When the Impressionists included shadows, these were full of reflected light and they were barely darker in tone than the sunlit areas.

A sketchy execution was essential to the painting's final appearance of immediacy.

The Impressionists presented a new way of painting the real world and the sense of wonderment in the legacy they left behind is a precious reflection of times gone by.

The outdoors revolution

The Academic teaching of painting demanded painting with studio lighting that was directional and had deep, well emphasized areas of shadow.

When artists painted landscapes in the studio it was difficult for them to achieve convincing, unified light. Everything changed when paint tubes were invented because it meant that artists were free to paint more conveniently outdoors

In nature, the gradations from light to shade are softer and the shadows are more diffused and filled with reflected light from the sky. Armed with their paint tubes the artists of the 1860s took to the outdoors where they were able to observe this and could retain the unity of natural light effects as well as the impact of their first impressions.

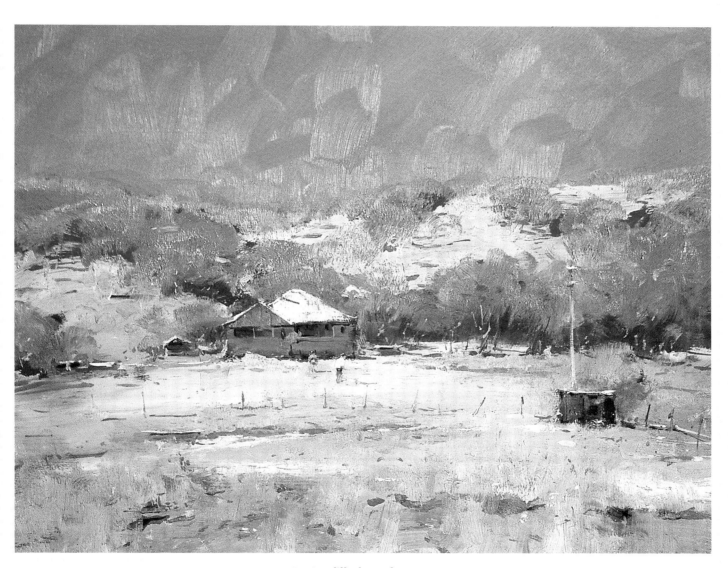

"A Sunfilled Landscape"

What do you see?

Let's see how these scenes were turned into

Photography has given artists a lot to be thankful for. Just looking through a lens to find the optimum view gives us practice in the art of composing. We are used to cropping photographs. And photographs make excellent memory jogging material. Of course, the light as seen in photographs is flat, all the edges are sharp, the colors are distorted and the shadows are reduced to dark, black or flat gray holes.

Scene photo
I was drawn to the subject by the sunlit foreground. My aim was to capture the tonal relationships between light and dark. The first thing to do when you look at a scene is to squint to identify the light and dark areas.

This is what you see when you squint
It's important to start thinking in terms of tones and shapes.

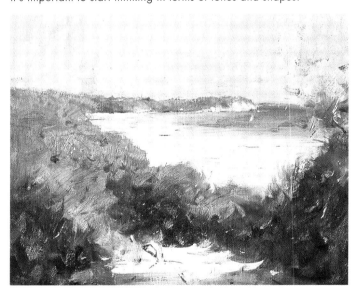

Paint to go!

In the 1860s, some artists were painting outdoors but they were forced to use a bulky, inconvenient bladder method of storing and transporting paint.

Then, while living in London, American portrait artist John Goffe Rand invented collapsible tin tubes for paint. This revolutionary device made it possible for legions of artists to take to the outdoors to paint on site in the different light conditions that so inspired them. These were the legendary Sunday painters who flocked to line the Seine and who are indelibly imprinted in our imaginations.

As well as tubes, a range of new colors became available to the Impressionists — Cobalt Blue, Ultramarine Blue (previously lapis lazuli), and the Chromiums: Yellow, Orange, Red and Green. All these colors had the stable drying properties so important for outdoor painting.

Another milestone was the publication in 1839 of a study of complementary colors by French chemist Eugene Chevreul, which paved the way for the Impressionists to use their characteristic colored shadows.

So, a new era in art began. With their portable easels and portable paints, Monet and Renoir painted side by side on the banks of the River Seine at La Grenouillère outside Paris. They made rapid studies in free, sketchy brushwork, attempting to capture the fleeting effects of sunlight on moving water. Although their styles evolved in later years, the foundation for the new Impressionist technique had been established.

impressionistic works

Now think in terms of color
This version shows you how the scene looks in terms of colored tones.

"Sunlight and Shadow, Victoria", 11 x 13" (28 x 33cm)
Here's my finished painting of the scene. Notice how the cliff face on the headland in the distance is a subtle mixture of Yellow Ochre and Cadmium Orange, with a touch of sky color added to give the effect of aerial perspective.

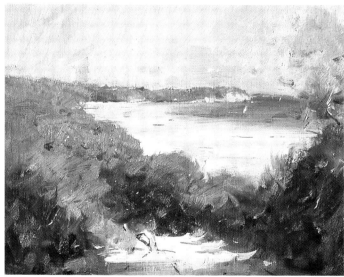

Without paint in tubes there would have been no Cézanne, no Monet, no Sisley or Pissarro, nothing of what the journalists were later to call Impressionism.

— Auguste Renoir

Squinting

When you are painting from life it is essential to squint at your subject. Squinting reduces the visual clutter and allows you to see the relationships between shapes, values, edges and color temperatures. Once you have identified them, you can introduce these elements into your painting.

Photo of the scene
The color of the sparkling water and sun-struck beach cabins attracted my eye.

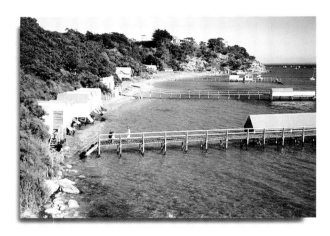

Tones and shapes

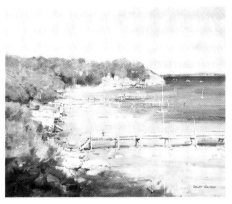

Tones and shapes

Photo of the scene

Color tones

**"Spring Light, Sorrento, Victoria",
13 x 15" (33 x 38cm)**
Notice how I left out certain objects that
did not suit my purpose.

Color tones

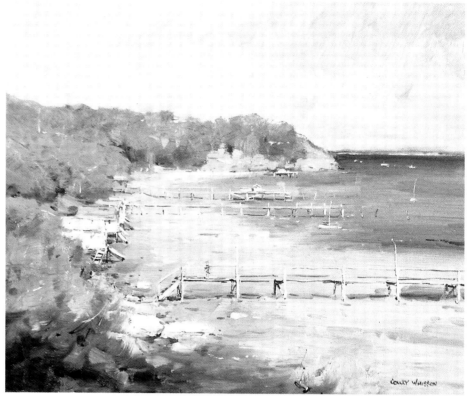

**"Stymers Creek, Queensland",
13 x 15" (33 x 38cm)**
This scene has a strong directional line
where the water meets the sand banks.
I used a few devices to slow the viewer's
eye down and keep it in the picture.
The area of foliage at the edges of the
sandy area keeps the viewer's eye in
the central region.

Photo of the scene

This was a natural composition, with its lazy S-shape leading the eye into the scene.

Tones and shapes

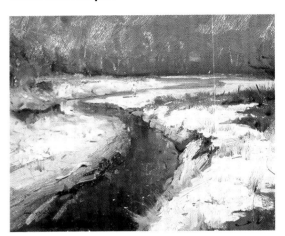

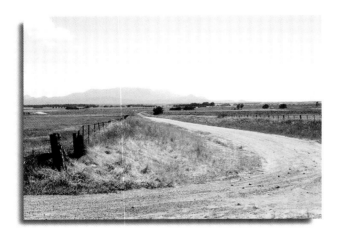

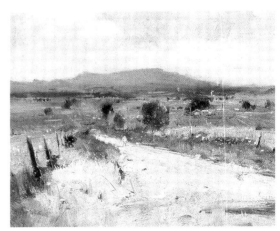

Photo of the scene

The colors of the road against the gray in the distance create an ideal contrast.

Tones and shapes

In nature, the gradations from light to shade are softer and the shadows are more diffused and filled with reflected light from the sky.

"From source to sea"
Notice how I added movement to the static sky, and introduced color into the shadowed areas. The figure and the posts add interest to the scene.

Color tones

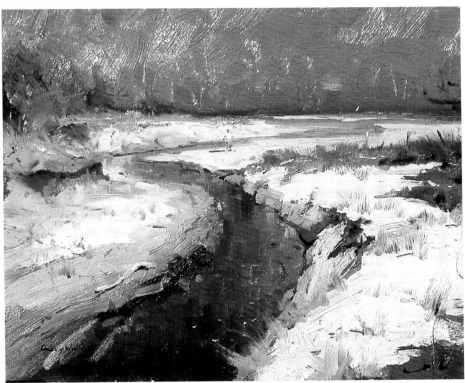

Color tones

**"The Road to the Grampians",
10 x 12" (25 x 31cm)**
My main concern was the strength of the edge of the road where it meets the grassed area. I made sure to soften any hard edges to reduce their visual importance.

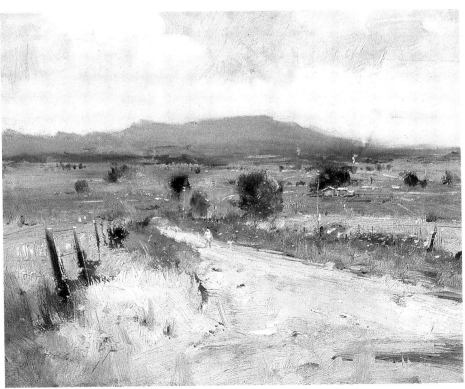

Scene photo
I particularly liked the contrast and color in the shade in this scene,
but I decided to choose only one segment of it, and try a different format.

Tones and shapes

Color tones

"North Stradbroke Island"
In this finished version you can see how
different the shadow color is. Always
remember that a photograph can deaden
and flatten colors.

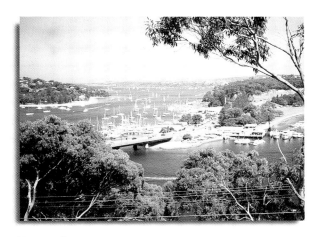

Scene photo
Obviously, this is a complex scene, so rather than paint every single piece of detail I took the liberty of reducing it to a series of shapes interspersed with highlights. Then I added a rusty-colored boatshed as a counterpoint to all that blue.

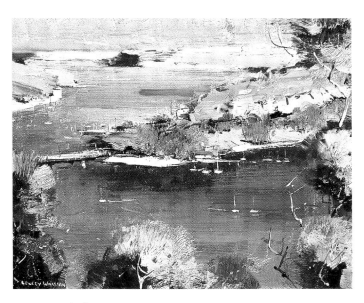

Tones and shapes

Color tones

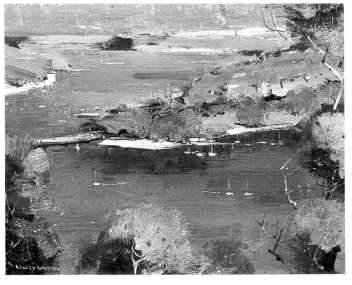

"The Spit, Sydney", 10 x 12" (25 x 31cm)
This scene is very well known to Sydneysiders and it has been painted by artists for over 70 years, most notably by Australian artist James R Jackson. I am reluctant to paint a scene that has such a rich history unless I believe I may be able to bring a new approach. The painting is almost self-explanatory, which is a rare occurrence when a composition needs only little adjustment.

Materials and formats the Impressionist way

THE KEY TO EXPRESSING YOURSELF WITH COLOR IS TO UNDERSTAND THAT COLORS HAVE DIFFERENT TEMPERATURES SO, TO MAKE YOUR PAINTING WORK, YOU MUST HAVE WARM AND COOL COLORS ON YOUR PALETTE.

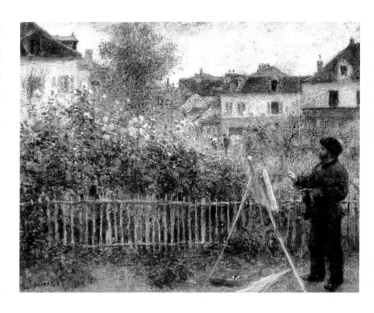

"Monet Working in his Garden", 1873, by Auguste Renoir

What is the first thing that attracts you about a painting? Think about it. Although you might respond to the subject because it has a powerful composition, and the shapes and tones are masterfully arranged, your initial, gut-reaction is evoked by the painting's color. Because color is directly linked to your emotions and your senses.

Color can be subtle or dynamic, garish or restrained — but it is color that sets the mood. Color will give your paintings their emotional value.

What the Impressionists discovered

Rather than painting a mass in one solid tone, which was the Academic tradition, the Impressionists conjured up a prismatic play of color within the shapes. This is because the Impressionists abandoned the studio and went outside to study the true colors of nature, and the light effects they saw while painting on site. In particular, they became aware of the complementary color in the shadows and the colors in the changing light as it bathed the landscape from dawn to dusk. The color of the light effects were more important to the Impressionists than the local color in their subjects.

What they discovered was this: in nature, cool colors recede and warm colors come forward. Their aim was to mimic the atmospheric condition that occur naturally and so they painted by juxtaposing different temperatures (warm/cool) of colors to suggest atmospheric perspective and to model form.

To paint in an impressionistic way, it will help you if you separate your colors into cool and warm ones, because it is how you position them next to one another in your painting that will give you the exciting look of an impressionistic work.

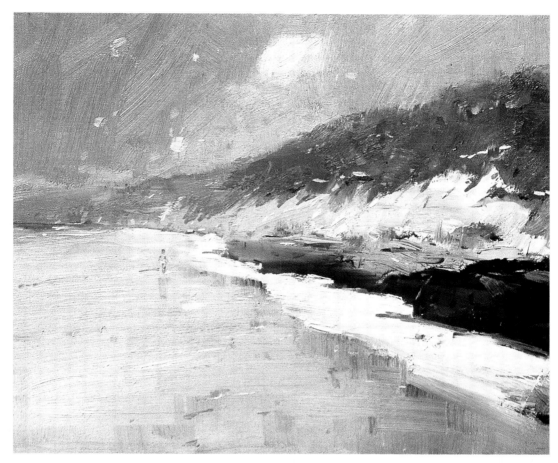

"High Tide, Rainbow Beach"

In fact, a color's temperature is a very underestimated part of color mixing, and color placement. We discuss this further in Chapter 6.

You can provoke mood in your painting by using more cool colors or more warm colors. But you have to have some of each. For example, in a work that has lots of warm color an expressive radiance seems to emanate from the painting. To prevent that radiance from overwhelming the viewer, you will need to place spots of cool contrasting color. The same is true when the majority of colors are cool — you will need a "spike" of warm color to liven the painting up.

It was because the Impressionists preferred to work with temperature contrast rather than with value contrast that they upset the Academic painters.

The Impressionists also preferred to work on pale or white grounds, and they worked with a restricted palette. They NEVER used black. They also tended to use opaque colors, which were lighter and brighter than those used by painters working in the Academic style. And, because they wanted light, bright pictures, they used lots of white.

The skill of suggesting mood and provoking emotional response in your viewer comes when you are completely familiar with the pigments, when you know what they can do, and when you have a methodical way of working. Experiment with your colors, practice, practice and practice some more, and then you will be able to choose colors you relate to, and by combining them with others in an expressive way you can fill your paintings with feeling. Color is really a personal choice, but to begin with on the following page I will suggest some colors you could choose for working in an impressionistic style.

Supports

Although we are borrowing from the Impressionists, we can still modify their approach to meet our special requirements. For instance, the Impressionists preferred to work on white or pale grounds because it suited the atmosphere of Europe, with its flat, consistent light. In Australia, where the sky is brilliant ultramarine blue and our vistas have lots of purple and blue in them, I often use a wood panel in a complementary color to our visual purples. This is what Australia's most famous Impressionist, Sir Arthur Streeton, did, so I make no apologies for following his lead.

Whichever colored ground you decide to use, depending on the special climate conditions in your hemisphere, is up to you. Try both approaches and see what appeals to you most.

The benefits of using a white ground

The Impressionists often used cream-colored grounds and allowed this to show through a loosely painted blue sky, full of roughly scumbled white clouds. This gave the optical effect of warm, glowing sunlight. Then they would enhance the cream by making it warmer and pinker against an adjacent blue, which would appear correspondingly cooler. Cream showing through the clouds would add an airy effect of warmth and the result would be an ethereal quality of light which is difficult

to achieve by a more conventional build-up of colors.

A white or pale ground acts as a luminous unifying field for brilliant light effects. The Impressionists dragged dryish colors mixed with large amounts of light-reflective lead white, which enhanced the pale, chalky paint surfaces.

Some Impressionists soaked the oil from the colors before use by standing them on blotting paper, this emphasized the chalky, pastel-like qualities produced by paint containing only a small amount of oil. The idea was to imitate the effects of pale, reflected light in nature.

Working on plywood

The main reason I use wood panel is because I think of the tone of the board as an underpainting and I let small areas show through.

Before working on a plywood surface I treat it with Orange Shellac and then allow it to dry for at least 24 hours. The best way to ensure that the coat of medium is even is to use a rag and lightly rub the surface.

Working on canvas

The Impressionists liked woven fabric because of its texture. When I work on canvas I use a polycotton type because of its longevity. I give the surface an undercoat of acrylic paint in whatever color or tone I prefer. Once the painting has dried, I glue it onto a hard board.

Medium and varnish

Archival Odorless Lean Medium is my preferred painting medium because it is simple to use.

When the oil painting has dried thoroughly I use Art Spectrum Dammar Varnish to protect it. This varnish is removable, which is an important point to consider.

Brushes

I use lots of brushes but I only use three pure bristle sizes: flats in size 9, 11 and 14 and a size 6 rigger. I use a medium palette knife for mixing.

I use a rag to clean my brushes. The only time I clean my brushes with turpentine is when the painting is completely finished.

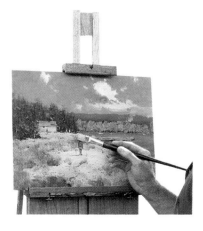

Suggested palette

I suggest you have a balance of warm and cool colors on your palette. For example, Permanent Crimson is a cold red while Superchrome Scarlet is a warm red.

You could do as I do and break my colors into three groups: cool, medium and warm tones. Remember, cool colors recede and warm colors advance.

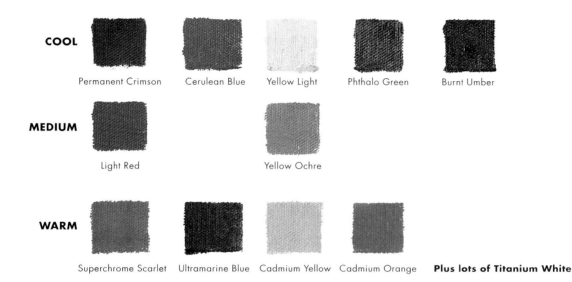

COOL				
Permanent Crimson	Cerulean Blue	Yellow Light	Phthalo Green	Burnt Umber

MEDIUM	
Light Red	Yellow Ochre

WARM				
Superchrome Scarlet	Ultramarine Blue	Cadmium Yellow	Cadmium Orange	**Plus lots of Titanium White**

The use of expressive colours is felt to be one of the basic elements of the modern mentality, an historical necessity, beyond choice.

— Henri Matisse

Friendly Advice

Color mixing tip

If you use a brush when you are color mixing you run the risk of allowing paint residue left on the brush to mix in with the new colors. Instead, use a palette knife for color mixing, wipe it every time you mix a color, and in that way you will keep the colors clean.

Choosing a format for your painting

The Impressionists experimented with different formats. Monet, Pissaro and Gauguin in particular enjoyed square paintings because it presented them with a composition challenge.

Here are some examples of formats you might choose. I think you will find that choosing a format that suits the composition gives you many more options.

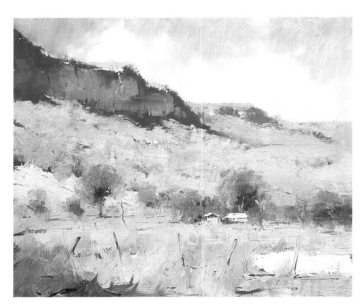

"Capertee Valley", 12 x 14" (31 x 36cm)
In this square-ish painting, I placed the focal point in the bottom one-third of the painting, a classic approach that retains the balance of the painting.

Composition plan

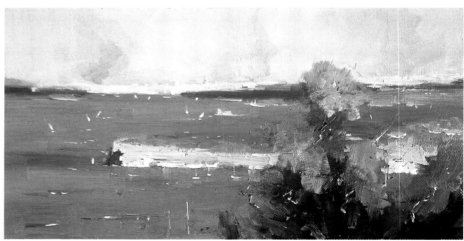

"Sydney Harbour"
This panoramic format emphasized the broad sweep of the Harbour looking out towards Sydney Heads. Again notice how I balanced the long horizontal shape of the main headland by using a strong area of vertical tree shapes. Dots of red and white highlights bring excitement to this scene.

Composition plan
Here, the headlands are ranged on the top one-third, and the highlights are on the bottom one-third.

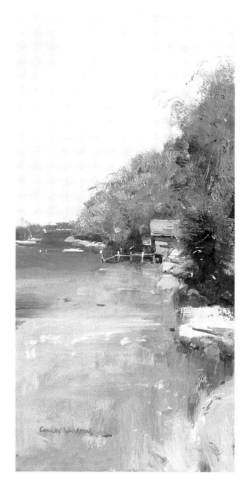

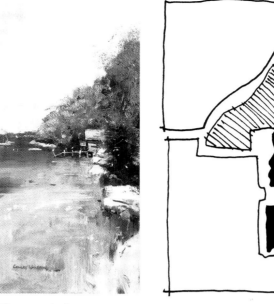

The tonal plan

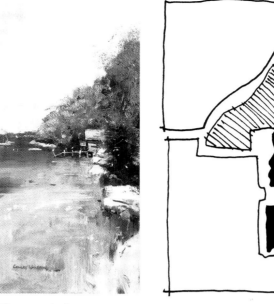

The shape map

"Tranquil Waters, Sydney", 16 x 7" (41 x 18cm)
This elongated approach presents some exciting design opportunities. I found that having a tonal value plan in my mind before starting was critical to this painting's success. By placing the darkest tones besides the lightest tones I achieved maximum tonal impact. The small boathouse was an excellent compositional element that breaks up the area of foliage. We will go into tone and shape in more detail later on.

"Sunlit Gums", 9 x 5" (23 x 13cm)
Here's another elongated painting. Even a painting this small can be packed with action. My challenge was to make sure the tones had depth in the foreground shadow area. The tree also had to have soft edges or it would look too stiff. I wanted it to make the gum look like a living being, always moving and growing.

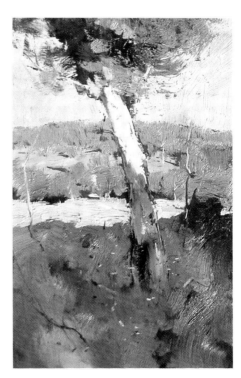

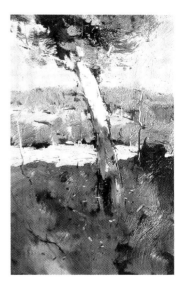

The tonal plan
Notice again how by squinting, the scene is reduced to abstract shapes.

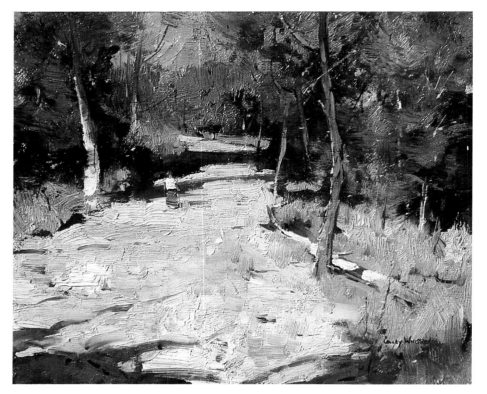

"A Country Road"

This painting was done from a photo I took in 1987 when I was on a sapphire fossicking trip with my brothers, Warren and Barry. I am not sure if I had a good eye for composition or merely a pleasant sense of the picturesque. It took me close to ten years before I had the control to do the scene justice — so the moral of this story is, be patient and practice.

Tonal plan

Shape map
Here I divided the square format into horizontal bands of color and tone.

"The Last Rays of Light, Queensland", 10 x 12" (25 x 31cm)

This scene is only five minutes away from my home so I am able to view it in many different lighting conditions. My first consideration in this painting was to set where the light was coming from. The next challenge was to manipulate the tones so there was depth in the shadow area.

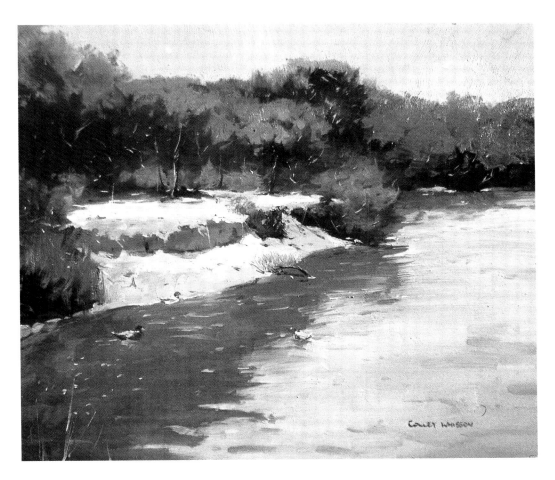

**"Stumer Creek II",
14 x 16" (36 x 41cm)**
This was an exercise in shape and tone. A square-ish format forces you to be more clever with your composition.

Tonal plan
Here's what the scene looks like if you squint.

Shape map

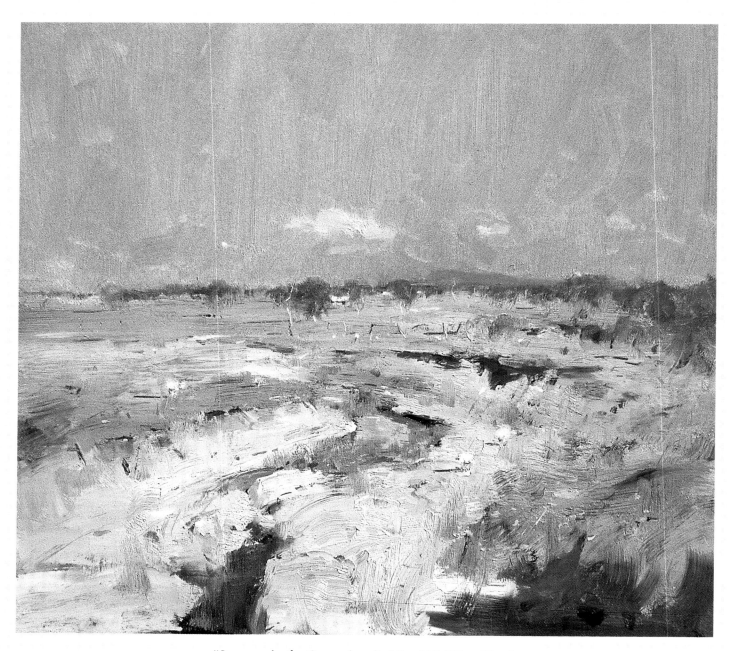

"Summer in the Grampians", 15 x 17" (38 x 43cm)

Impressionistic Painting Techniques

Checking your thought patterns

IF YOUR PAINTINGS
KEEP COMING UNSTUCK,
AND YOU ARE CONTINUALLY
DISCOURAGED, IT COULD
BE THE WAY YOU
ARE THINKING THAT
IS THE PROBLEM.

**"A Road in Louveciennes", 15 x 18¼"
(38 x 47cm) by Pierre Auguste Renoir**

Whether they are impressionistic or not, I believe some paintings are doomed from the start because the artist hasn't made time for preparation. It helps to have a plan. Each painting requires the artist's undivided attention. You have to think about it.

During the initial phase of any of my paintings, my concentration is enormous. Even though I may be driven by my mood on any given day, my approach to each painting is similar. I find the subject usually chooses itself — some play of light, a fascinating shape, a color effect, a place that tells a story — then I make preliminary sketches to get to know my subject. What is the light doing? What are the shapes telling me? Where are the lights and darks?

My focus right at the beginning is to get the composition under control. I can deal with the mood and color temperature later.

I admit I am mostly "composition driven" and feel design is very important for a painting because a clever or correct layout will help your work stand the test of time.

Subject selection is important too, because it provides a secure foundation. When I am composing I find the painting has a better chance of working if there are fewer elements competing for attention.

When choosing a subject I use my eye just like a zoom lens on a camera and I identify the most exciting aspect. I select a single focal point and do not paint everything I see because it can be overwhelming; there's just too much to think about.

If I am working from photographs taken on a lengthy trip, back home in my studio I make drawings from the photographs first because this familiarizes me with the subject and helps me get all the proportions of light and shadow correct. My aim is to bring form to the photograph's flat plane.

I find my concentration remains constant throughout the painting and climaxes in the closing moments with fine-tuning. I am patient during the working phase and try to save my spontaneous input for the final stages.

Enhancing composition

My aim to work most of the painting in a loose, impressionistic style contrasting with a focal area of tight detail.

The focal area will have the lightest tones beside the darkest

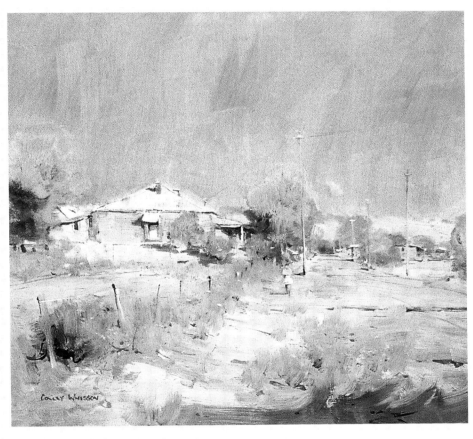

tones and this, combined with sharper edge brushwork, should lead the viewer's eye directly to one point; everything else should be secondary.

To achieve a balance in my composition every object needs to be taken into consideration. When beginning a painting, depending on the subject, I place the major objects in a one-third, two-thirds position (see chart) while aiming to keep any major objects away from either the dead center or the outer edges of the canvas or board.

I use directional lines to lead the eye to this main focal point and subtle lines lead away from the focal point to a secondary point. In a more subtle painting a grouping of flowers may provide a suitable lead-in. There are many other examples of ways to control the viewer's eye, but the key to good composition is balance.

A piece of advice given to me was that no two objects should be the same size, shape or distance apart. The best way to explain this is by imagining a horizontal line of fenceposts. Of course, usually they would be placed an equal distance apart and they would all be the same height. A line like this can create a composition problem by cutting the painting in half. Instead I use artistic license and leave out the occasional post and give the remaining posts a gentle lean, aiming to make them look more randomly positioned. Doing this will provide a more balanced element in my painting.

Another element of good composition is grouping. Whether it be fenceposts, figures or sheep grazing I try to place them in groups of odd numbers.

By following these tried-and-true methods my work tends to have natural balance.

Impressionism doesn't mean being thoughtless

Just as you can't be a concert violinist until you know your scales and can read music, you can't be a good artist until you know the fundamentals. Nobody would pay to go and listen to a violinist who just scrapes away on the instrument, no matter how much feeling they put into it. So why should people buy paintings that have no underlying understanding of the principles of composition, tone and color?

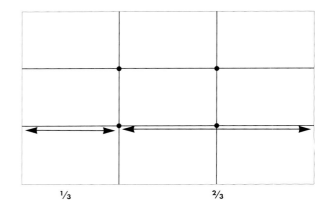

One-third composition diagram

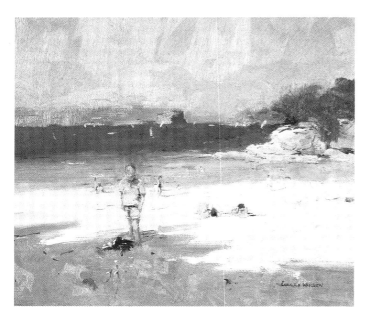

Tonal plan

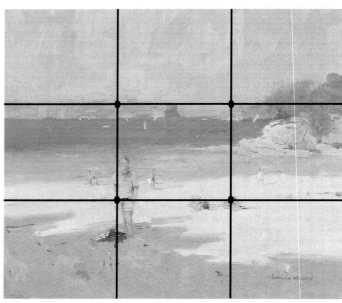

Composition plan

Painting an impressionist work doesn't mean just painting what is there. You still have to use your sense of composition to present the scene in the best possible way.

Eliminate mistakes right at the start

I believe good painting is mostly about eliminating mistakes. The best painting has the least amount of errors. Most mistakes happen in the initial drawing stage which, when you think about it, is the time you can most easily make changes because this is when most of the pushing and shoving takes place.

Thinking about eliminating mistakes is a useful way to approach a subject, because it ensures you pay attention to the areas that are not quite working. If something is wrong with the drawing, fix it immediately, rather than just letting it be and learning to live with it.

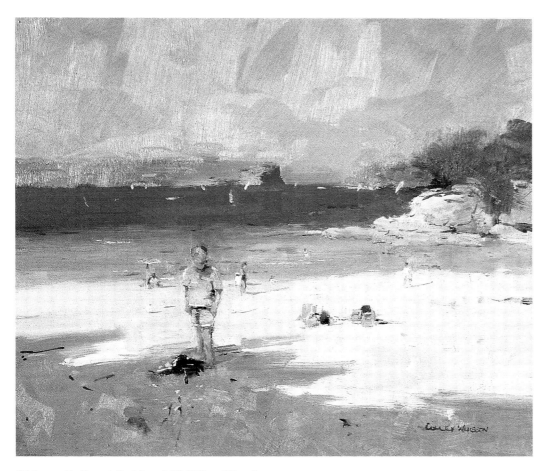

"Edward's Beach", 13 x 15" (33 x 38cm)
The grouping of the figures is what interested me the most with this scene. The afternoon shadows fell across the foreground, creating an ideal tonal contrast. The boats in the distance added interest to the background.

Identify the most exciting aspect, select a single focal point and do not paint everything you see.

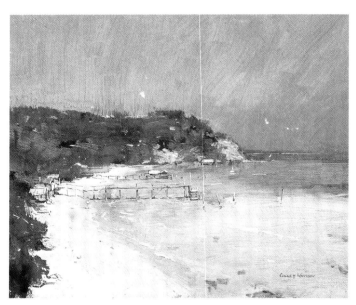

Tonal plan

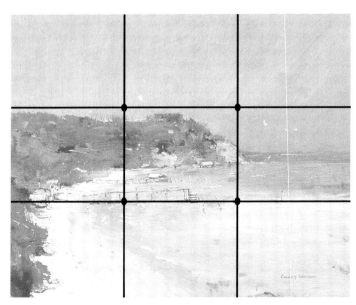

Composition plan

Tonal plan

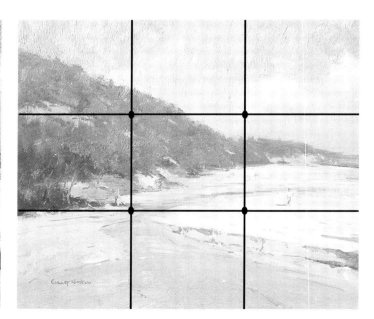

Composition plan

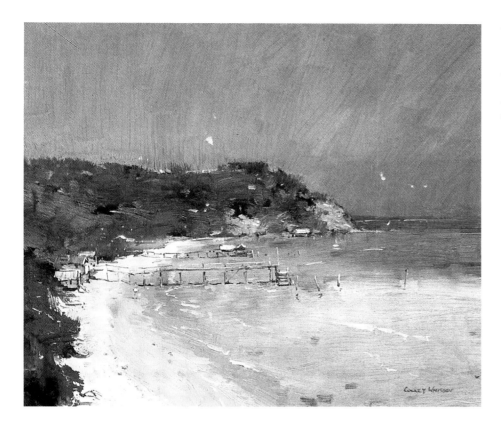

**"Secluded Cove, Victoria",
11 x 13" (28 x 33cm)**
It was close to high noon when I stumbled on this scene. Except for the foliage, boat houses and the jetty, there was a general lack of contrast. This meant I had to search for accurate tonal control right from the start.

CHECKLIST

✔ Pinpoint what it is about the scene that stopped you in your tracks.

✔ Make preliminary sketches.

✔ Devise the best composition you can.

✔ Highlight the most exciting aspect.

✔ Strike the optimum balance between light and shadow.

✔ Ensure objects have variety in shape, size and distance apart.

✔ Group objects carefully.

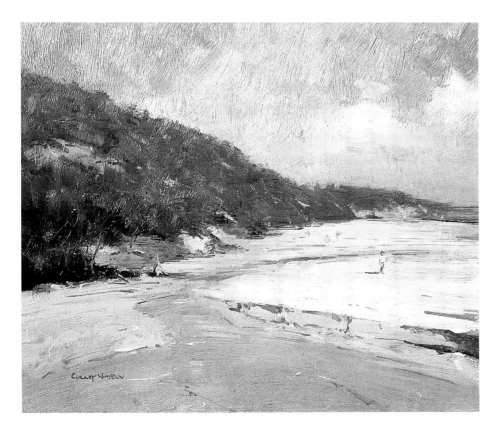

**"Rainbow Beach, Queensland",
11 x 13" (28 x 33cm)**
This stretch of Queensland coastline is quite spectacular. The sand required careful thought otherwise it would be too cool in tone and the painting would look flat.

What is the light doing? What are the shapes telling me?
Where are the lights and darks?

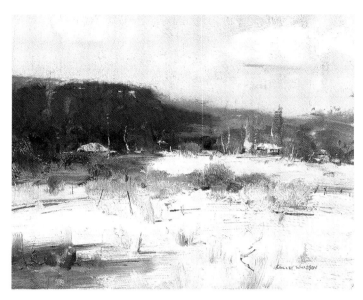

Tonal plan

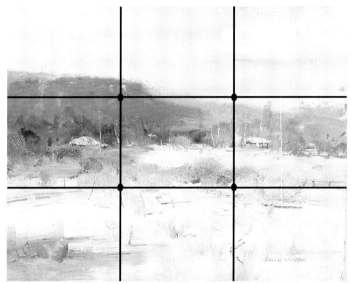

Composition plan

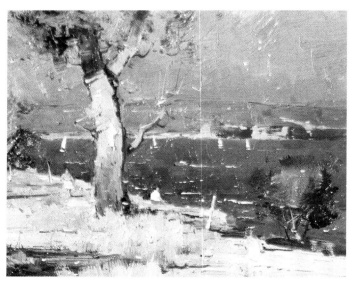

Tonal plan

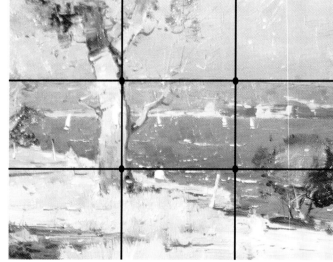

Composition plan

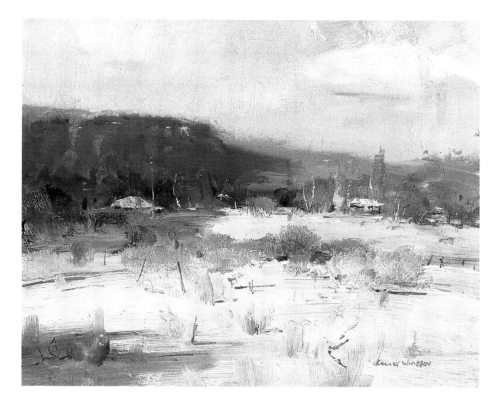

"Sunlit Landscape, New South Wales", 10 x 12" (25 x 31cm)
To me this is what landscape painting is all about — strong sunlight and quality shadows. The golden poplar tree in the distance is a marvellous element that helps capture the viewer's eye. Overall, this subject is Impressionism at its finest — a fleeting moment caught when the elements were at their best.

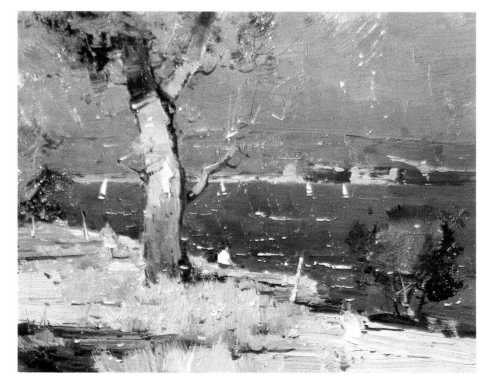

"Behold the Golden Moment"
This magnificent gum tree, standing sentinel over Sydney Harbour represents a strong vertical on the left one-third line. A small shrub balances it on the right one-third. The strong V-shape of the water is complemented by three dots of orange-red.

Drawing steals the scene

ARTISTS OFTEN OVERLOOK ITS ADVANTAGES, BUT REGULAR PENCIL DRAWING BUILDS YOUR CONFIDENCE SO YOU CAN MAKE QUICK PLANS OF THE LIGHT AND TONE TO DEVELOP INTO FUTURE PAINTINGS.

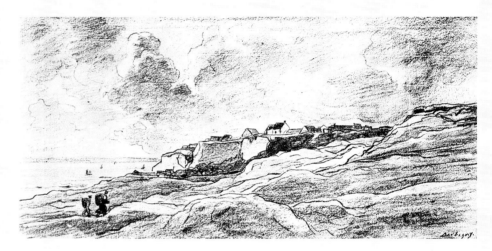

"The Cliffs of Villerville", by Charles-François Daubigny

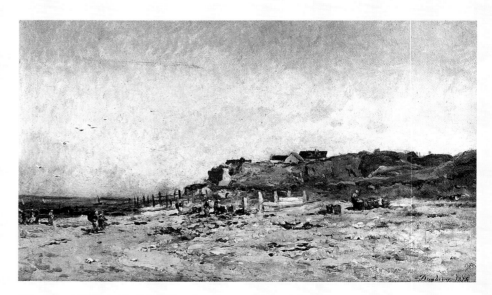

"Beach at Villerville" by Charles-François Daubigny

My purpose as an artist is to capture the beauty and elegance of my surroundings. However, to be able to do this I have to build a solid foundation for my paintings— and drawing ability is that foundation.

In order to bring out the best in the scene, you need to be able to "see" it in artistic terms and then be able to assess it. Drawing will speed up the process.

I look at the world as if I am searching for drawing subject matter. My ultimate aim is to be as efficient as possible in analyzing the scene and I often see things as if they were snapshots of finished works.

I strongly suggest you sign up for as many drawing lessons as possible, because your confidence will grow with your skill, and finding subjects to draw will become easier.

There's no need to drive for miles to find a subject, in fact, you can flex your creativity by devising new ways to portray familiar subjects. When I first began drawing, I used to just grab my gear and walk across the road from my home to a vacant paddock where there was a wealth of trees and old farm sheds to sketch.

Drawing is often overlooked for many reasons, but I use it to keep my confidence intact. I believe that if you have confidence in your ability to draw your subject matter will no longer intimidate you.

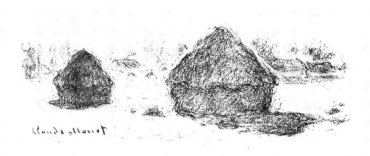

"Hay-ricks", by Claude Monet

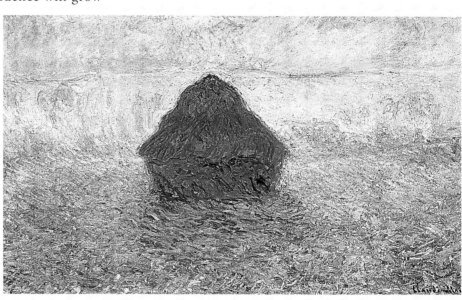

"Grainstack; sun, misty twilight", by Claude Monet

With each subject I choose to draw, I start from a single viewpoint and work away from there, not trying to fill the rest of the page with detail. If the original viewpoint is exciting enough it will easily hold the picture together.

Drawing is the secret to artistic success

Times have changed. Materials have changed. Names of movements have changed. However, there is one constant in art and that is the ability to draw — consider Michelangelo, Da Vinci and Degas — this skill is a marvellous gift to have and you can learn how to develop it if you practice.

Drawing ability will help you enormously when you are assessing subject matter. In fact, the drawing stage is probably the most crucial time in a painting's life. Drawing will help you compose and place tones correctly so you will need to train your eye by scheduling regular drawing sessions.

Early in my career, drawing was my weakest discipline, so I set out to improve this aspect of my work. I scheduled a month of intense drawing, then a month with oils, then another month of drawing — and I did this for two years. I quickly noticed big gains in my work. My control of tone and composition began to show some promise.

*There is a hidden contradiction in their art:
they observed reality with precision in order to extract the
poetry of everyday life from it, and yet they froze movement,
the moment, in order to fix what was temporary.*

Develop your drawing skills

The simplest way to begin a painting is to make a pencil drawing to help you work out the composition and the tone. Learning to draw before you paint is like learning to walk before you can run. Being confident in your drawing ability will translate to the canvas.

Take a class

It's important for your development to be presented with new and different ways of working. Take regular lessons, attend painting seminars or even better, take an overseas painting holiday. A trip I made to Italy and France was a real turning point in my development.

The accidental tourist

An experience I had some years ago reinforced how important drawing is.

I was scheduled to go on a painting trip to Italy and France. Unfortunately, the day before departure I managed to cut my finger badly enough to need seven stitches. Although it was not my painting hand, it was still going to make painting almost impossible, and my life as a traveling artist frustrating — especially when confronted with all those paintable scenes in Europe. On the tenth day I was able to attempt some work but my confidence had evaporated. I decided to go back to basics — I would rely totally on drawing to lead my recovery.

In hindsight, some good did come from the enforced break. In all I had five weeks lay-off from painting, but I was able to manage plenty of drawing, in which time I regained my confidence and was able to return to painting with fresh ideas.

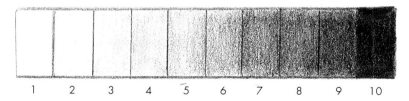

The tonal scale
Here is a tonal chart divided into tones from very light, #1, to very dark, #10. Most people don't take advantage of the entire tonal value range when they are painting. They not only leave out the very lights, but they forget about the darkest darks. Drawing will help you establish a full tonal range.

Tonal exercise
Try drawing an egg using the tonal value scale. Notice how my egg includes very dark tones and very light tones — even though most of us think of an egg as being cream colored or brown.

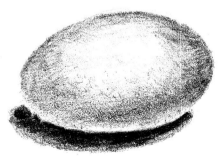

48

Most people don't take advantage of the entire tonal value range when they are painting. They not only leave out the very lights, but they forget about the darkest darks.

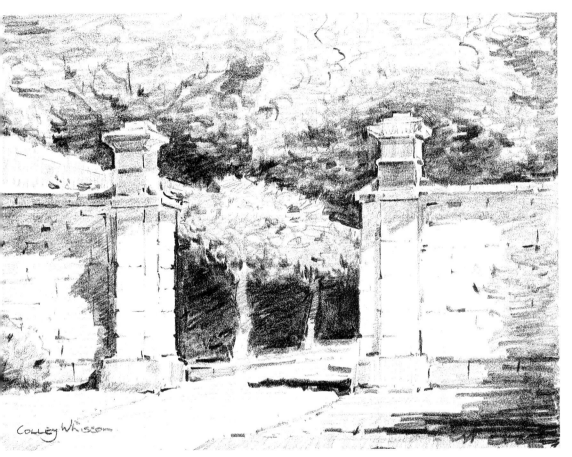

"The Grand Entrance, St Remy, France"
This drawing provided a good opportunity to create a light effect that enhanced the background as the most crucial area. Tonally, I needed strength in the background to hold the drawing together. I was aware that the brick wall was a rigid element that could demand too much attention, and with this in mind I tried to soften any hard edges, because hard edges attract the eye.

All you need

2B and 4B pencils
Smooth grade paper
A kneadable eraser
A good sharpener

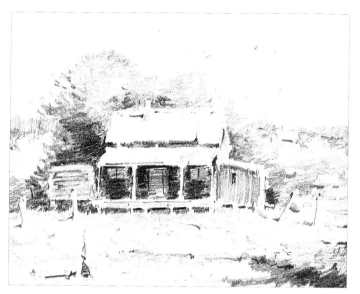

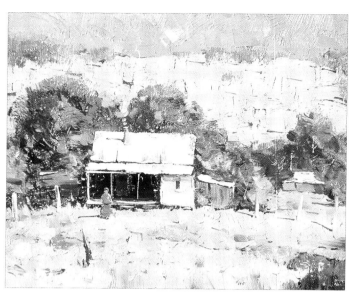

"The Old Homestead"
I enjoy drawing for many different reasons — sometimes it helps to get my mind working but mainly drawing helps to test the tonal balance and light effects.

Tonal plan
Showing the evolution from drawing to painting.

"Exhibition Building"
I find most good subjects are approachable from many different angles, which is definitely true of this one.

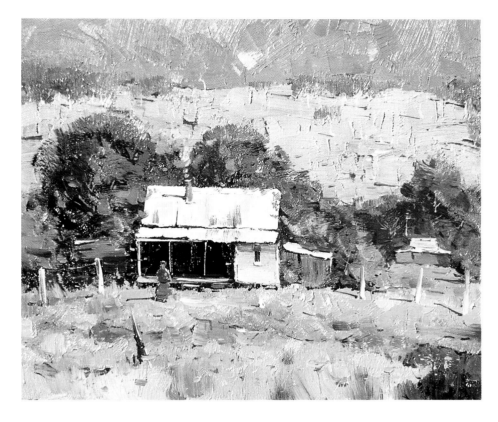

You can only paint as well as you can draw.
— C. W. Mundy

"Pioneer Homestead"

"Balmoral, Sydney"
This area of Sydney has a wealth of material in almost every direction. Balmoral bandstand is a constant delight for visitors and is a favorite site for wedding parties.

Friendly Advice

Find a mentor

One of the things that will help you develop as an artist is to find a mentor who is an established artist and who will give you constructive criticism. No matter what your standard of work, and even if the improvements your mentor suggests are only minor, you can always learn something — even the smallest piece of advice will help you in your search to reach a higher level in your art.

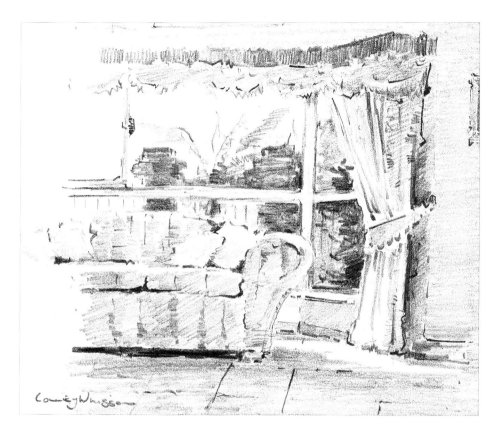

"Looking out of my studio window"

Sometimes a subject can be right in front of your eyes. Keeping an open mind is essential for the improvement of your work. This drawing worked because I made the armrest of the lounge the focal point, and made everything else secondary.

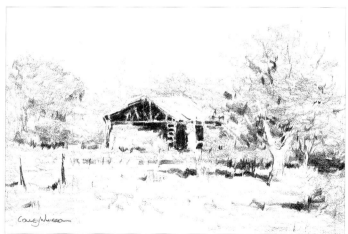

"Victorian Landscape"

I enjoy the sheer thrill of being able to create useful working drawings that translate into full paintings later.

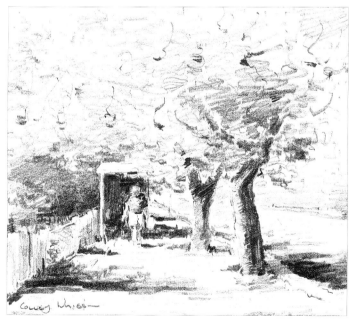

"Red Hill, Queensland"

I found this scene outside one of my galleries. The bus stop frames the focal point nicely and casts a helpful shadow. The fence and kerb bring the viewer's eye down to the figure.

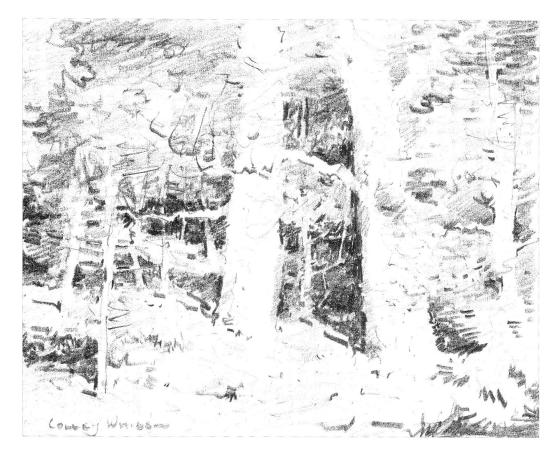

"North Stradbroke Island"
The sunlight was striking the gums nicely, giving them a dynamic light effect.

This drawing was a good test of my ability to cope with a scene that was mostly foliage.

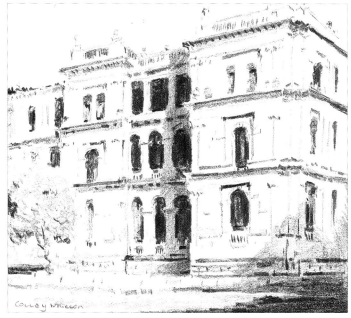

"The Treasury Building, Brisbane"

CHECKLIST

✔ Start from a single focal point and work out from there.

✔ Make an interesting tonal plan that includes very dark and very light tones.

✔ Pay attention to how you group the major shapes.

✔ Make sure there is a lead-in to the focal point.

✔ Sketch the same scene from different viewpoints.

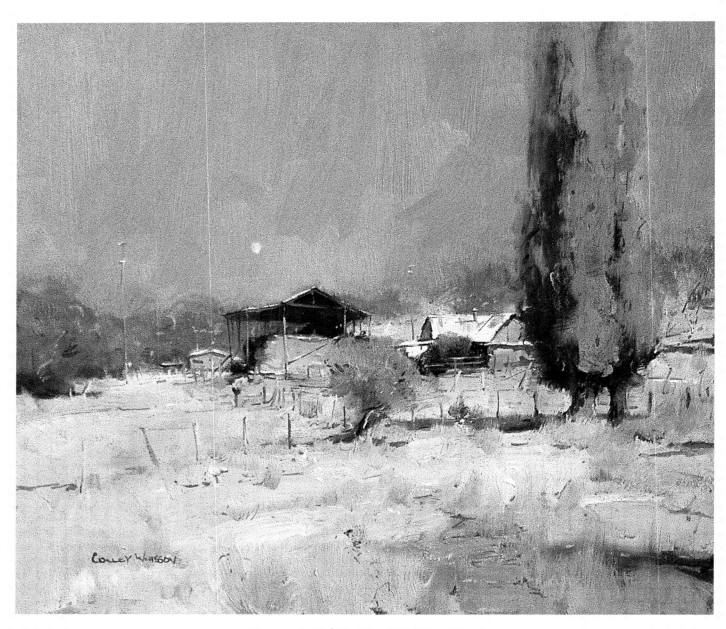

"Summer's Light", 14 x 16" (36 x 41cm)

Demonstrations

Painting a light effect

HAVING EXPLORED THE SUBJECT IN TERMS OF A TONAL PENCIL DRAWING, NOW IT'S TIME TO TRANSLATE THE BLACK AND WHITE TONES OF THE SCENE INTO GLORIOUS TONAL COLOR.

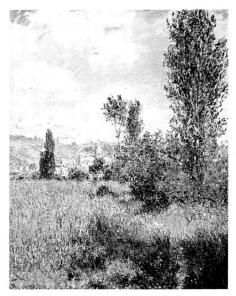

"Path in the Ile Saint-Martin, Vétheuil" by Claude Monet

Unless you can recognize and introduce subtleties of tone in a preliminary pencil drawing, you will really struggle when it comes time to paint the light effect in color.

The most important point to consider in your endeavor to paint light, or a light effect, is to plan your approach. It is essential to have a finished image fixed in your mind and work towards that vision. That's why it is so important to practice your pencil drawing — because a drawing actualizes your vision.

The next important point is that the light direction needs to be consistent throughout the painting. The fact that you can get a light effect to work on a preliminary pencil drawing tells you that your most crucial task is to control the tones in the light and dark range.

Whenever I think about paintings that have been executed well, I keep gravitating back to the benefits of drawing, and the concept of tonal range. If you can imagine laying the tonal range down with the lightest tones in the distance and the darkest tones at your feet, just as happens in aerial perspective, you will have the basis of sound working principles.

"Spring in St Remy, France", 8 x 10" (20 x 25cm)

The fact that you can get a light effect to work with a pencil drawing tells you that the most crucial element in a painting is tonal control in the light and dark range.

Understanding tone and color

The accompanying black and white tonal chart shows all the tones needed to produce a successful drawing. It is just a matter of knowing how much of each tone to apply. But, as I often say, most people don't go light enough or dark enough in the tonal range. An understanding of light and dark tones is the fundamental building block of a successful work.

When it comes time to converting tonal drawings to color you must make sure that you use the complete range of tones, not just the light and dark ones.

Let's look at the tone of a color
The top strip shows tones simplified from very light to very dark.

The strip below shows how a color would look in tones from very light to very dark.

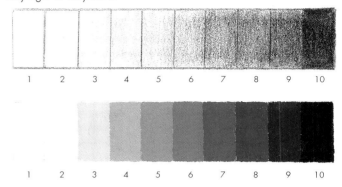

Make way for a breakthrough

Practicing with simple still life subjects is one of the fastest ways to improve your skill in capturing light because you cannot rely on tricks to make the painting work. The still life may be as simple as a vase with a restricted arrangement of flowers. I know this works because, after about 12 months of trying and failing to paint seriously, I attempted a small 20 x 15cm (8 x 6") still life. It took me eight hours before I could get the painting to work, but when I had finished I felt as if I had been given the key to a treasure house of ideas. It was a huge turning point and it had an enormous impact on my confidence.

However, I discovered an even more crucial aspect, and one well worth considering. The element that impresses me the most about the artists who have taught me, or the artists I admire, is their discipline. This discipline begins with control of their working environment and continues with the determination, and patience, to see things through to the end of the painting. One artist I particularly admire for his discipline and control is American artist, Richard Schmid. His work epitomizes everything that is good in art. If you ever get a chance to see any of his paintings, I recommend careful study.

In Australia we have many excellent artists and a few that I believe require special mention are Hal Barton, Dale Marsh and Les Graham. These artists reinforce the belief that working in tried-and-true principles will help you achieve your goals.

Practice tonal drawings on still lifes

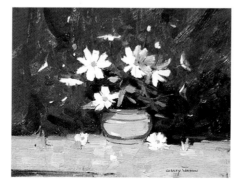

Then paint using the drawing as reference for the colors

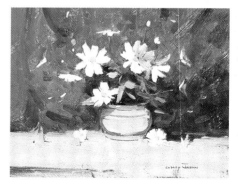

Tonal map

Here's how a similar still life turned out in terms of tone. Still life painting is a marvellous challenge, it requires good tonal control because, with only a small tonal distance to contend with, there is no room for complacency. The arrangement of flowers is crucial because they direct the viewer's eye around the picture to one focal point.

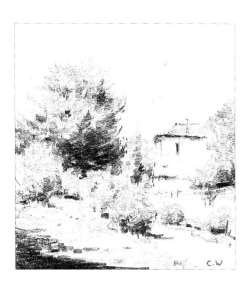

A preliminary tonal sketch of a scene
Here's how I produce tonal drawings. This one is only about 5 x 4" (13 x 10cm) but it validates my composition idea and gives me the complete tonal range.

Let's pretend we painted this scene in color
To illustrate that color has tone, we have superimposed a mid tone shown opposite over this sketch. Do you get the idea?

"Capertee Valley"
With this drawing I was searching to capture the texture of the foliage in the she-oak tree in the foreground. Placing a small house in the distance helps to create a good perspective effect in this drawing.

Let's pretend we painted this scene in color
Because I did my homework where tonal value is concerned, this scene will translate immediately into color.

"Morning Shadows, Hahndorf, South Australia"
The shadows enhanced this captivating subject. If you want to be a good painter of light you will need to have a good understanding of shadows. Your education begins with plenty of drawing.

Let's pretend we painted this scene in color too

Temperature

The other important consideration when translating a scene into color, is that in order to create a believable light effect, both warm and cool tonal ranges need to be combined.

The term *color temperature* refers to the relative warmness or coolness of a particular pigment. Hues in the red-orange-yellow-brown range are referred to as warm colors. Those in the blue-green range are called cool. Yet there are degrees of warmness or coolness. For example, Yellow Ochre is a warmer yellow than Lemon Yellow. Similarly, Phthalo Green is "colder" than Olive Green.

To create the illusion of distance it is critical to use cool tones in the background and warm tones in the foreground.

So you can see that warm and cool color plays an important role in depicting natural light.

The distinction between warm and cool color also makes it possible for the eye to distinguish between very subtle nuances of color, with imperceptible contrasts of tone. Color contrasts and juxtapositions of warm and cool colors were used by the Impressionists to suggest form without conventional tonal modeling. This is possible simply because warm colors appear to come forward and cool colors appear to recede. In nature, warm yellow sunlight finds its contrast in the luminous blue-violet reflected light of the shadows. So, where colors are equivalent in tone but show warm/cool contrast, these can be used to describe form or movement. The inherent tonal differences can then be exploited.

In the color spectrum, blue is a relatively dark tone compared with pale yellow. These colors together provide pure, luminous equivalents for traditional dark/light contrasts, and give structure to form.

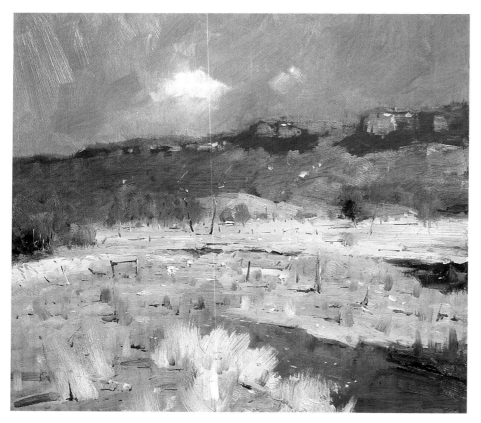

"Captured by the Charm of Capertee", 10 x 12" (25 x 31cm)
This scene required some understating because the foreground tends to compete with the distance. With this in mind I paid extra attention to the tonal relationships, aiming to soften the shapes in the distance. I believe one of an artist's best attributes is the ability to solve any problem that may arise. There are times when you have to go where the painting is leading you, even if it is slightly different from your first idea.

Tonal map

"Spring in St Remy, France", 8 x 10" (20 x 25cm)
Some subjects are inspired purely by my fascination for a particular element of the landscape. Here it was the olive trees that captivated me. This is a fairly simple subject, and there is not any obvious focal point. The villa is only just visible through the foliage. After achieving a decent light effect with the olive trees I decided to add a figure in a complementary tone to bring the scene to life.

Tonal map

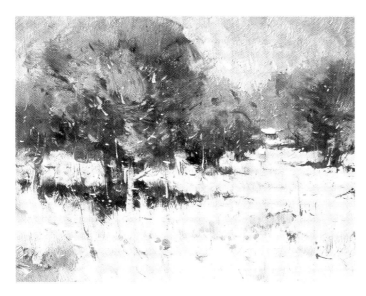

Turn your finished painting upside down
A good test of tonal range is to view your finished painting upside down, then you will not be distracted by the objects. Another way to get the same effect is to view the finished work in a darkened room, which is similar to squinting your eyes to reduce the tonal range, but without the eyestrain!

Reflected colors

In nature, the gradations from light to shade are softer and the shadows are more diffused and filled with reflected light from the sky.

The Impressionists questioned local color. In reality, every object is modified by reflected colors from surrounding objects and by the colored atmospheric light or sunlight. The Impressionists put down the colors they saw, not the colors they knew, for instance, green for grass, yellow for lemons.

Light

There is a huge difference if you paint with the light behind you shining onto the scene — there's a lot more color, about four or five times as much in the overall saturation of color. This leads to greater contrast of light and dark, leading to harder edges.

Friendly Advice

Peace of mind

When starting work for the day, make sure you are relaxed and your mind is not stressed-out with all the worries of everyday life. Take five minutes in a quiet spot to gather your thoughts and focus your efforts before you begin painting.

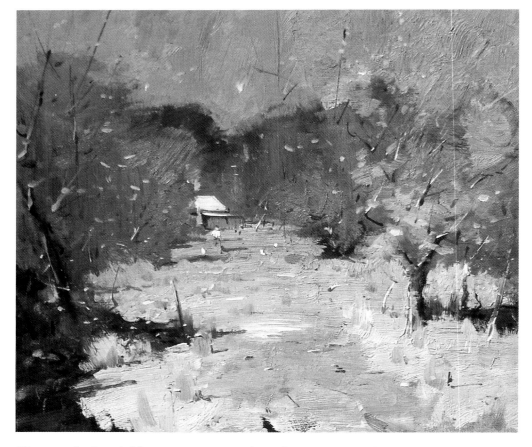

"Among the Peach blossoms, New South Wales", 11 x 13" (28 x 33cm)
I was waiting at the roadside for a friend to give me a ride. I was worried that I might miss them, but I also felt this scene was too good to pass up. I made a quick tonal sketch and painted this later. Whether it is an olive, apple or peach grove, in my mind these orchards have a natural energy that only add to a painting.

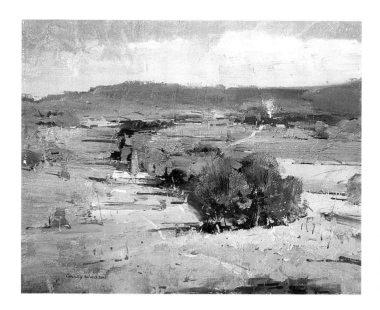

"Autumn Glow, Lilydale, Victoria", 11 x 13" (28 x 33cm)
Whenever I get into a car and drive on a painting trip it seems to be a voyage of discovery. When my wife and I were returning from a trip to the Victorian ski fields I was rather disappointed. The weather had been terrible, with only a few breaks in the thick fog to reveal, overcast skies. Then, a few days later we drove into this delightful valley. It certainly made up for our previous disappointment.

Tonal map

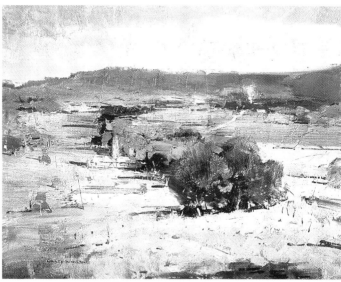

Turn your finished painting upside down to see tonal balance

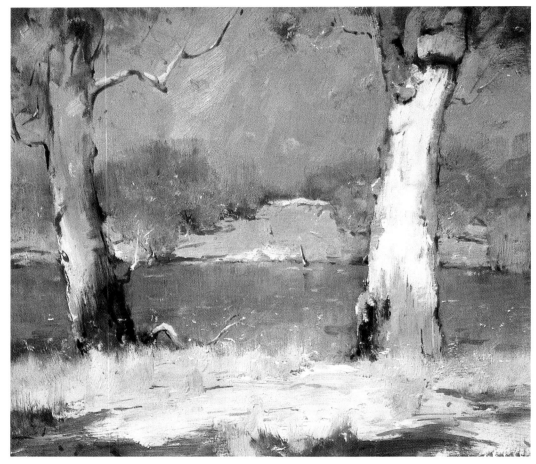

"Gums by the Murray River"

Friendly Advice

The big test for any painter is how to place the big areas of color

I advise you to put color in the shadows, because this is the secret to greater depth. The more depth you can get in the shadows the better.

I like direct, vibrant, raw color. I like scenes full of light because I can get a greater brilliance of color.

Because of the strength of the light in Australia, I tend to use stronger shadows than would be used in Europe, which has a softer, diffused light.

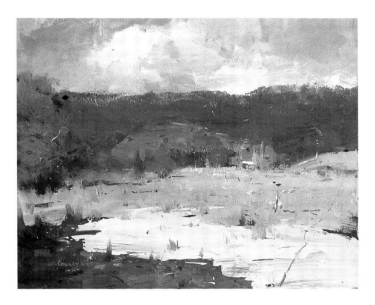

"Fall at Alexandra", 11 x 13" (28 x 33cm)
Timing is important. A knock-out scene may depend on the time of the year or the time of day. Because I knew this part of Victoria, I tried to time our trip when the fall colors would be on show, especially the golden poplars. Unfortunately, the weather can throw all your planning into disarray. When the sun did come out it was like turning on a light in a darkened room. Under these light conditions, if you can remain patient you can sometimes get spectacular results.

Tonal map

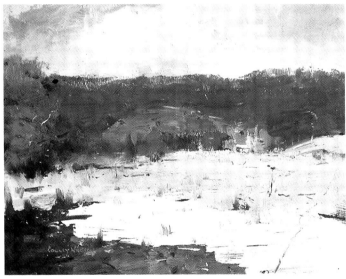

Shape map

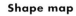

Searching for basic shapes

Blocking-in

First, I squinted at the subject to establish the tones and shapes. I washed in using equal parts of Ultramarine Blue and Permanent Crimson, pushing the paint around the board with a large No. 9 brush.

Establishing distance

Because the subject was going to be rich in color I had to be careful not to make the picture look like a candy-box image. For the sky I used Ultramarine Blue and Permanent Crimson with plenty of Titanium White. My aim was to get the effect of color recession from the horizon line to the foreground.

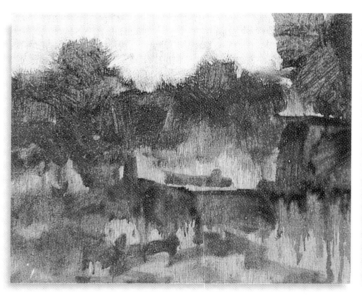

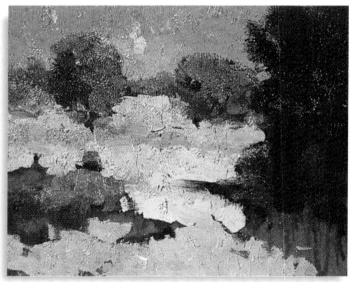

Shape mapping

When you are mapping tones, look for good contrasts. Squinting your eyes right down will reduce all the shapes to varying tones from black to white. Pick all the very dark tones and assign a shade to them. Apply light tones to the lighter shades. Merge shapes that are alike in tonal value into larger shapes. It's always a good idea to connect shapes into single large shapes. Here you can see one light tone trapped in a dark connected shape.

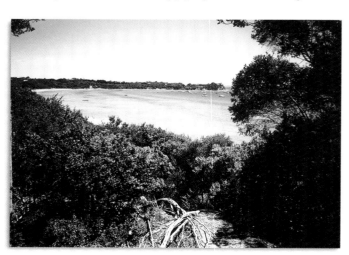

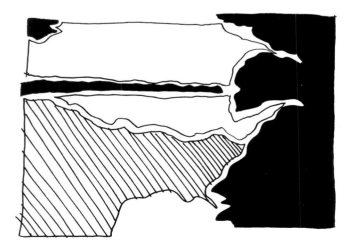

Reaching my favorite part

The foliage was made from Ultramarine Blue, Cadmium Yellow and Light Red. The shed is important in this design because it helps the feeling of perspective. The foreground was the most enjoyable part of this painting — the broken earth gave the picture more interest. I added the fence posts, chickens and placed the essential figure.

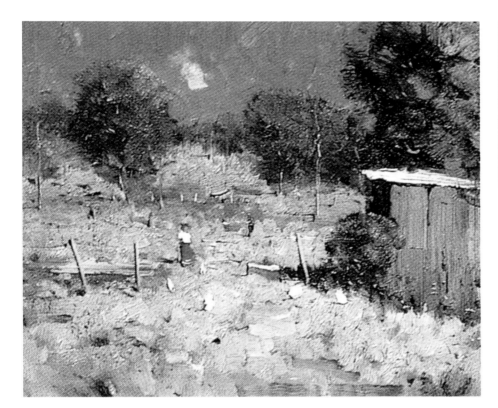

Tonal plan

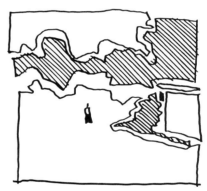

Shape plan

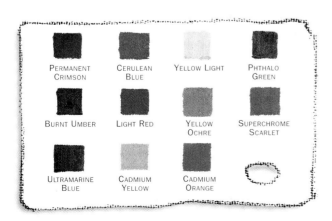

PERMANENT CRIMSON

CERULEAN BLUE

YELLOW LIGHT

PHTHALO GREEN

BURNT UMBER

LIGHT RED

YELLOW OCHRE

SUPERCHROME SCARLET

ULTRAMARINE BLUE

CADMIUM YELLOW

CADMIUM ORANGE

Turning everyday subjects into impressionistic works

"Argenteuil", by Claude Monet (1872)

IMPRESSIONISTIC LANDSCAPES APPEAL TO THAT SPECIAL PLACE IN THE HEART — THEY STIR UP OUR HOPES AND DREAMS AND REMIND US OF TIMES GONE. THERE ARE SEVERAL ELEMENTS THAT MAKE SUCH LANDSCAPES SUCCESSFUL, AND IN THIS CHAPTER, I WILL SHOW YOU WHAT THEY ARE.

To me, impressionistic landscapes are all about wishful thinking. They are about memory, nostalgia and about our yearning to find a sense of peace and tranquillity through the beauty of nature. These paintings are powerful on many levels. They represent a way of life that many people wish they had, instead of the crowded, busy reality they deal with on a daily basis. As such, these paintings are balm for the soul because they "verbalize" something many individuals would like to experience. They also remind viewers of something from their own lives — whether the stirred emotion is remembered or imagined. Impressionistic landscapes appeal to that special place in the heart.

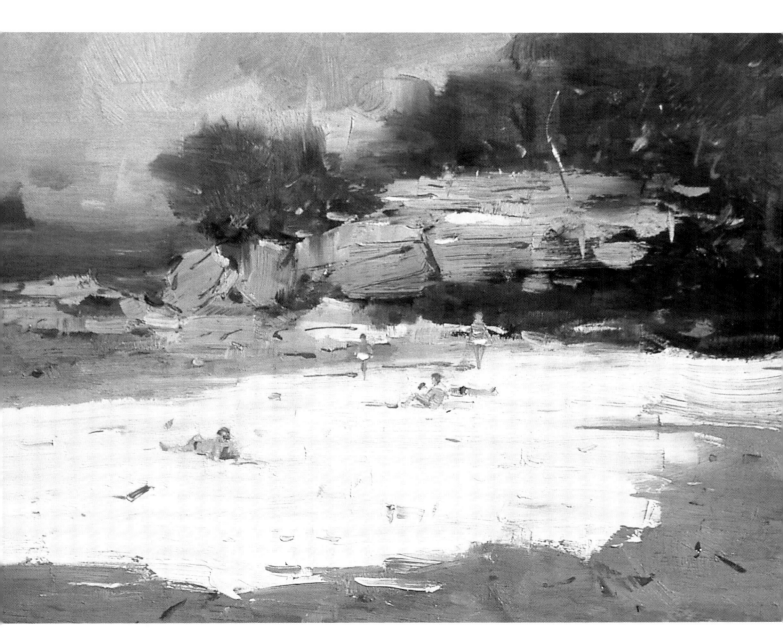

"Edwards Beach Idyll"

"A Time of Innocence"

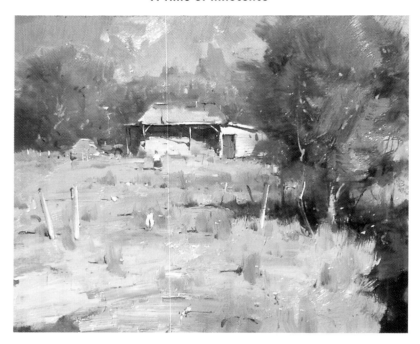

You will see a pattern of light and dark shapes. Some of the shapes are objects and some are the result of light and shadow.

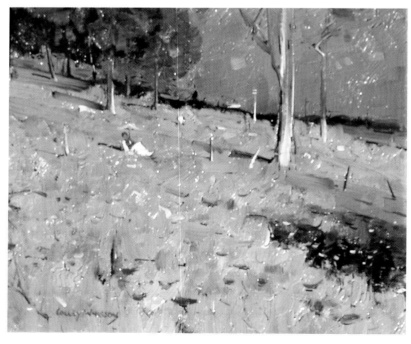

"Enjoying the Sun"

How to evoke a reaction

You don't have to do very much to create an impressionistic landscape. As the name suggests, the beauty of working impressionistically is that you can suggest a mood by careful composition, with color and tone, with brushwork and, of course, with light!

Figures play a major role in my paintings. The first thing the human eye looks for when gazing at the landscape is signs of life. Evidence of humanity (cabins, smoke curling from a chimney), add to the story. Introducing a figure is a great manoeuvre, and we will expand on figures in a later chapter. Animals also help capture or suggest atmosphere, and I am reminded of many paintings by my countrymen, where the masterly play of light on cows and horses has told a powerful, evocative story.

In fact, an impressionistic painting works best if it has a story — but try to have only one story, because one strong idea translates into a powerful painting.

The job of the impressionist painter is to say just enough without forcing the story on the viewer. Provide only enough building blocks for them to fill in their own story. Let the viewer's imagination have its head.

Treat impressionistic paintings carefully. Choose the subjects carefully and treat them sympathetically. Don't overdo detail because detail kills imagination.

"Pioneer's Dream"

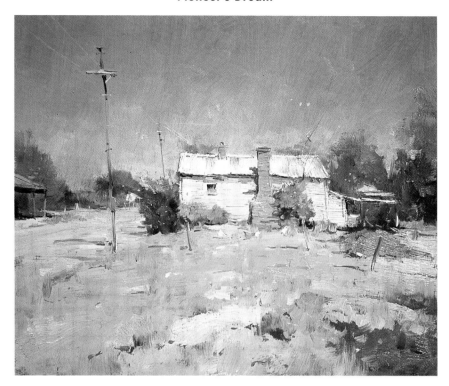

Most artists don't take advantage of the entire tonal value range when they are painting. They not only leave out the very light but they forget about the darkest darks.

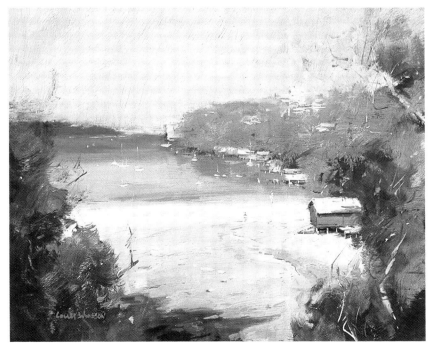

"Shell Cove Memories"

Impressionist landscapes simplified

Every landscape can be reduced to a wonderful and diverse collection of shapes — but to make a painting work you must manipulate and tie those shapes together in a pleasing composition.

As we have discussed previously, when you squint your eyes right down you will be able to identify the tonal value range of your subject. You will see a pattern of light and dark shapes. Some of these shapes are objects like trees, cabins, boats. Some of the shapes are the result of light and shadow.

As I said earlier in this book, most people don't take advantage of the entire tonal value range when they are painting. They not only leave out the very light but they forget about the darkest darks.

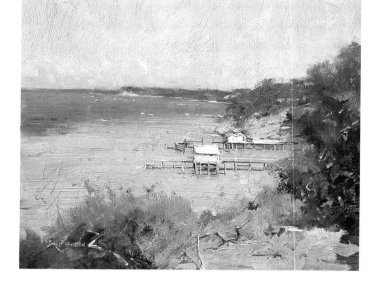

"Warmed by the Sun"

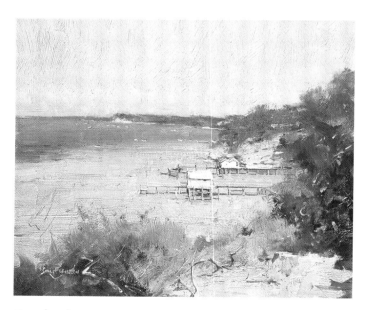

Tonal value map
Here is the tonal value map of the painting. Notice that the focal point, the hut at the end of the jetty, is the lightest light. The surrounding sea is also light, to draw the eye to the focal area.

Shape map
These shapes work to suggest recession. You can see the definite planes — foreground, middle ground and background.

Tonal value map

"Mid-morning in the Country"

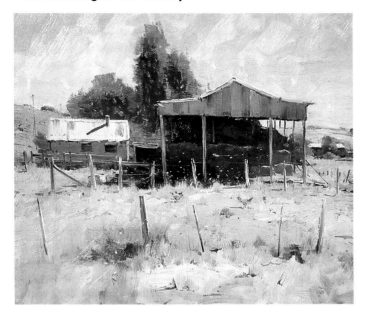

Shape map

Here you'll see how the illusion of recession was helped by dividing the painting into planes. The first plane is the foreground fenceline and band of darker grass; the second, the fenceline and main shed, where recession is aided by the deepening shadows in the barn. Notice that the shadowy interior is not black. Further recession was achieved by the smaller building in the distance and the muted down tree. Receding power poles lead the eye to the far distance where the objects are much smaller and grayed down.

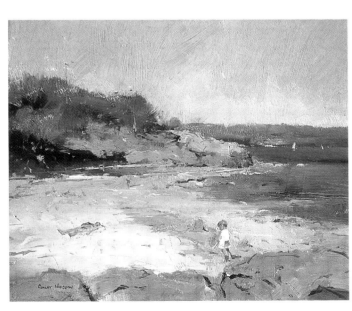

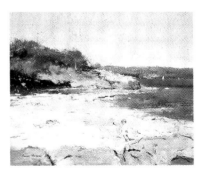

Tonal value map

"Secluded Beach"

Shape map

Here I achieved the illusion of distance by controlling the size of the figures, by making warmer colors in the foreground and cooler colors in the distance. (Remember that warm colors advance and cool ones recede.)

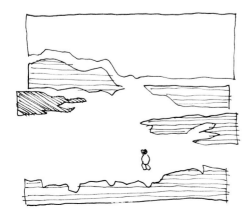

Identifying the elements of a powerfully suggestiv

*T*here are many elements you can use to tell a story in your impressionistic painting. Of course, this is not a prescription, because your own personality and sympathetic interests in nature and life will color the way you paint. All I am saying here is that there are certain things that are powerfully suggestive when it comes to painting an impressionistic landscape.

Here are some elements that can be helpful

Wildflowers, golden meadows, the pounding of the sea upon the rocks, a sandy path that winds along until it disappears over a hill, the brilliant colors of the

foliage in spring, summer and fall, the black branches of winter, snow, meandering streams, the way a cloud floats in a pure ultramarine blue sky, the mysterious effects of mist, the time of day — dawn, noon or sunset. All these elements have a profound effect on the psyche.

The story idea can be complex or simple, but try to avoid the mawkish, the candy box look. You can tell a powerful, nostalgic story with a lone tree standing sentinel on a rocky crag. Or you can fill the canvas with a riot of happy color.

How you place the elements is important. Consider size and shape, color, texture, light and dark, contrast, repetition, balance, harmony, tonal value, line, direction, size, dominance, balance, gradation, variation, alternation — even the way we use edges can help us say what we want to say.

Everything you do must enhance the painting in some way. But remember to leave something for the viewer to connect with from their own experience, then your painting will appeal to many levels of each viewer's memory.

Let's examine the accompanying painting and identify the elements that make it successful.

First of all, there is a figure standing patiently beside an empty boat. What is she doing? Is she waiting for someone? She's looking out across the water. Why? The figure is small in scale, emphasizing her aloneness. A high viewpoint exaggerates this even more as we look down on the figure.

There is no detail anywhere. The impressionist painting differs from reality and so details are its enemy.

Seemingly random dots of red and yellow generate excitement and serve as counterpoints to the tranquillity of the scene.

The shed increases the feeling of mystery because we can't quite see what's inside its dark interior.

painting

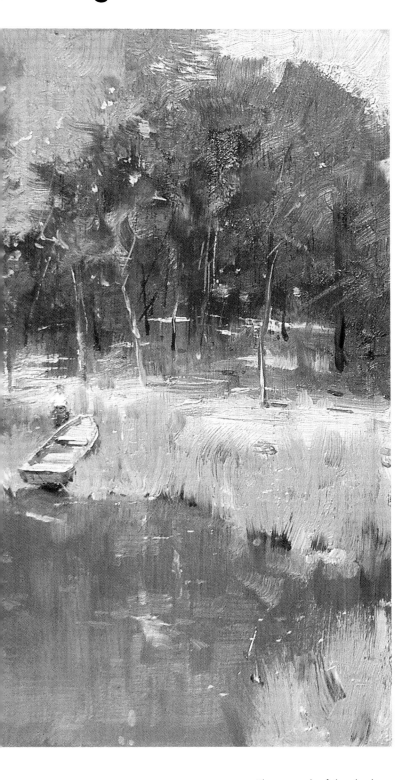

The sky color is repeated not only in the water but in the foliage, creating harmony, which is essential to this style of painting.

There is a sense of quiet, stillness and expectation.

The warm grass color is repeated in the tree foliage, and the same grayed-out color used in the background enhances the feeling of recession.

The vertical brushstrokes in the foreground grasses are repeated in the tranquil water, then the eye is carried up to the figure. The vertical repetition in the almost calligraphic trees serves to unify the painting.

Brushstrokes in the foliage are much more expressive.

Highlights on the low jetty, the boat and on the curved background hill add interest and give a feeling of warmth and light.

The composition has a series of curves which are emphasized either by patches of dark or streaks of light.

The strength of the shadows suggests it is late morning and suggests part of the story straightaway.

Assembling the elements

Telling an Impressionist Story

It was the foreground that struck me when I came upon this scene in France — a beautiful drift of tall grasses in an olive grove surrounding a charming villa.

It was a great scene, but a little too neat and tidy for my liking — which is always a signal for me to improvize.

A solution to relieve the vast foreground was right at hand. About 50 feet away, some blood-red poppies were growing wild and I photographed them as a reference for later — but what this scene really cried out for was a figure.

For this story I chose to add a solitary female figure striding out through the stone gate pillars of the villa, which were also my inventions. Perhaps the woman is escaping her work for a while? Highlights on her shoulders and jeans convey the warmth of the sun, and her bright yellow top suggests that she's happy as she walks knee-deep through the riot of flowers that "dance to the music of spring". Directly on the path in front of her, a small deciduous tree has performed the annual miracle of transforming itself from dormant winter starkness into a riot of pink blossoms. Is that what is happening for the woman? Is she walking happily towards a new future?

The essence of a nostalgic impressionist painting is that it should ignite memories and stir an emotion in the viewer. You don't have to spell the story out in detail, just a suggestion is all that's needed for the viewer to recollect a time when perhaps they left all their worries behind and went for just such a carefree walk in a spring meadow.

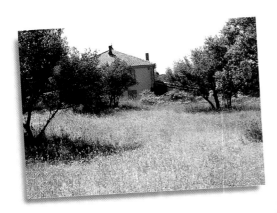

A great scene, but there was something missing

Look what I found when I investigated the nearby area

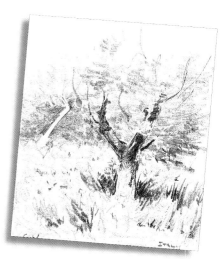

I used the drawing I made of the poppies in another painting

What the artist used

Brushes: Sizes 11 and 14 pure bristle
Size 6 rigger
Medium palette knife
Mineral turps
Odorless lean medium

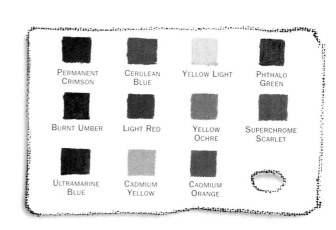

PERMANENT CRIMSON | CERULEAN BLUE | YELLOW LIGHT | PHTHALO GREEN

BURNT UMBER | LIGHT RED | YELLOW OCHRE | SUPERCHROME SCARLET

ULTRAMARINE BLUE | CADMIUM YELLOW | CADMIUM ORANGE

The first key — tonal values

When beginning this painting I paid particular attention to the buildings because the shadows created by the roof on the walls of the villa would be important in the overall tonal value relationship plan of this painting.

I wanted to establish the concept of foreground, middle distance and distance. I covered the blank wooden board with a turps wash. Most wash-ins don't look very exciting, but as long as I get the essentials down I'm happy. I let the wash dry for about 10 to 15 minutes until most of the shine was gone. You'll notice some dribbles of paint. These don't worry me because I cover them up later.

Interconnecting tonal shapes

I began the next stage by building up the tonal values in and around the villa.

I find painting on wooden panels adds an extra element of enjoyment to my work. Look at the swirls of the grain. You could try this painting on a colored ground, and then on a white one to see the difference it makes.

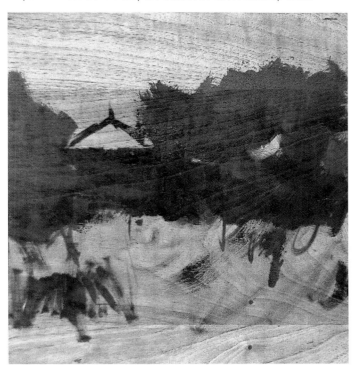

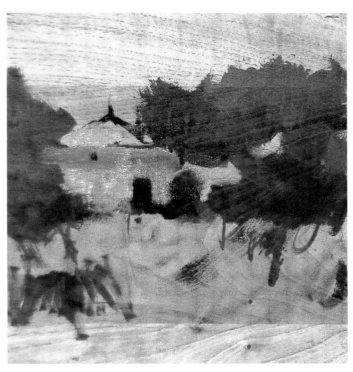

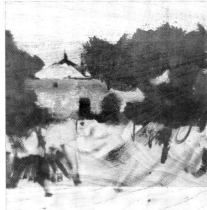

Tonal value map

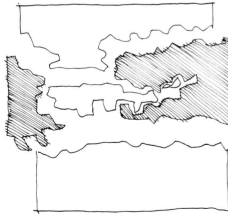

Shape map

When you are mapping tones, look for good contrasts. Squinting your eyes right down will reduce all the shapes to varying tones from black to white. Pick all the very dark tones and assign a shade to them. Apply light tones to the lighter shades. Merge shapes that are alike in tonal value into larger shapes. It's always a good idea to connect shapes into single large shapes. Here you can see one light tone trapped in a dark connected shape.

Painting the sky

I mixed up plenty of sky color (Titanium White and Ultramarine Blue), and brushed it on using a big brush. The villa was next. I did some "artistic building" by extending the structure so it didn't look so "boxy". I made a much bigger deal of the little lean-to. Shape has a lot to do with Impressionist painting. The roof tiles were a delightful terracotta tonal value, which I knew would give this painting definite impact. Next, I began building up the foliage. My aim was to get a feeling of light and depth.

Adding the figure

Then the element that attracted me to this scene in the first place — the foreground grass area. It was important to get the tonal value relationship right. I worked up the grassy area and included some dabs of red. All the while, I frequently stood back to assess the tonal value relationships and I carefully considered where I would include the important figure that I knew would add impact to the scene. I introduced some suggestions of detail in the villa, the shutters and doors, and added the stone color for the "conjured up" wall and pillars.

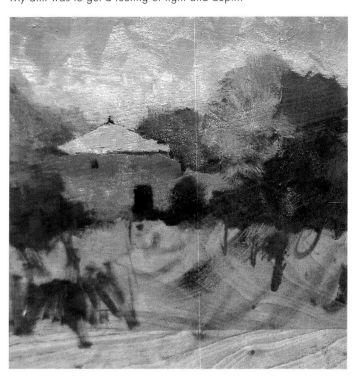
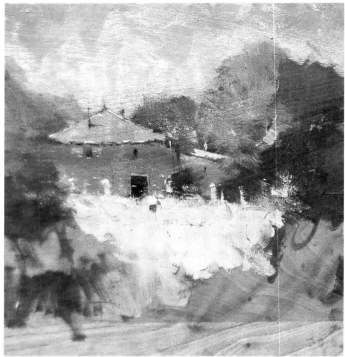

Friendly Advice

Adopt a review process

- When you've finished the painting, take a break of about 30 minutes to relax.

- Ask a trusted person for a critique — try to be dispassionate about this process. Don't take what they say personally because they are trying to be helpful.

- Check the painting yourself by viewing it over your shoulder through a mirror. This is a sure-fire way to see if the overall balance of the painting is correct. Trust your instincts.

- Walk backwards and forwards to alter your viewing distances from the painting.

- If you are not completely satisfied with your work this time, remember that the person who perseveres is the one who succeeds.

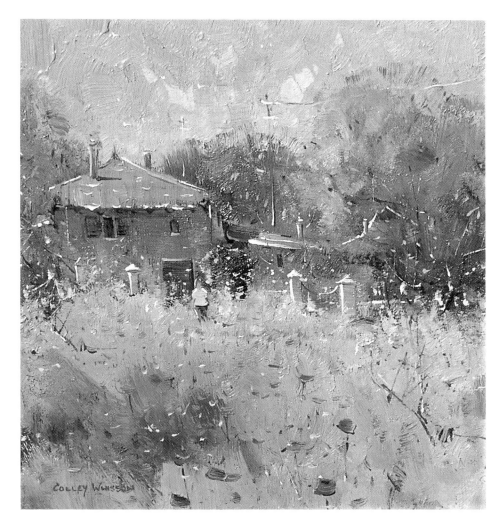

Going wild with color

My brushwork became more delicate to coincide with the overall feel of the scene. The illusion of depth was helped by making the poppies in the foreground bigger and more distinct than those in the distance, which were mere smudges of muted color. I connected passages with bright dots of yellow, added highlights here, there and everywhere, including the stonework. More highlights were touched to the roof gutter in such a way that they emphasized the cast shadow areas. Notice that I didn't attempt to paint every roof tile. A make-believe power pole gave the composition some vertical lines and echoed the chimneys and stone pillars.

I drew in the almost calligraphic structure of the small blossoming trees in the foreground and added pink flowers. I kept going until I had achieved the overwhelming profusion of color and life that spring means to me. Then I made the finishing touches to the figure.

I called the finished painting **"Flowers That Dance to the Music of Spring — France", 13 x 11" (33 x 28cm)**

What would this painting say without the figure?

With the figure gone, half the story is gone. It's still a spring picture, but now the eye skips over the foreground and goes directly to the villa door. The figure is necessary in this composition because it adds to the feeling of recession and provides a resting point for the eye on its way to the villa.

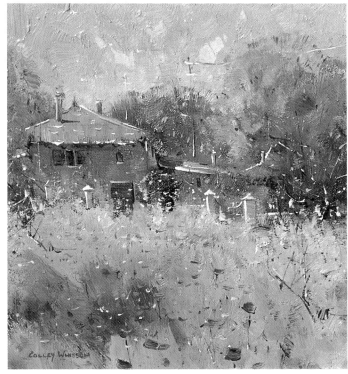

Developing your pictorial thought process

HOW THINKING IN TERMS OF
FOREGOUND, MIDDLEGROUND AND
BACKGROUND CAN HELP YOU INVENT
A SCENE WHEN THERE'S APPARENTLY
NOT A WORTHWHILE SUBJECT IN SIGHT.

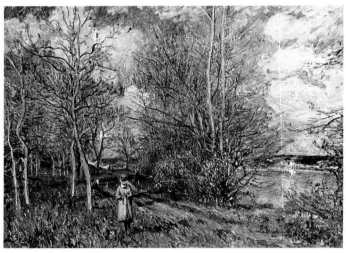

**"The Small Meadows in Spring",
1882-85 by Alfred Sisley**

Sometimes there's not an epic painting in sight — or so it seems.

You might be in the most beautiful place in the world but you may still be unable to frame the "perfect view", the one that constitutes the classic scene. This problem is called "setting your sights too high" and it can prevent you from working with many excellent scenes right under your nose.

The reality is that with a small amount of alteration almost any scene can be turned into a marvellous work.

In the past when I found a promising scene I would often say to myself, "If only that tree were in a different place, then I could paint the view". I have since developed the ability to idealize any scene by searching for its maximum potential. By doing this I can make the scene work for me. I am not afraid to move elements to suit my purpose. Some scenes only need a small amount of alteration but all scenes have to be treated individually.

I have developed and honed my creative instincts so that I have learned to see the germ of a painting in any scene.

"Looking Across the Valley"

Developing pictorial thought

I don't know how you imagine Venice, but when I arrived we had dull, overcast days the entire time. So much for my preconceived idea of azure skies, sunlight striking the buildings and diamonds of light twinkling on the water.

So, to make the most of my visit, a fair bit of inventing was required. I make no apologies for straying from what I saw in front of me. If the end result is truthful enough I feel justified.

The scene
This scene may not look too inspiring, and the poles in the foreground are overwhelming but there's a lot that can be done with this scene just as it appears here.

Here, I have cropped out the distracting pole on the right and zoomed in on the scene, this gives us scope to play up the brushstrokes in the foreground. Notice in the painting opposite that I substantially reduced the size of the pole in the foreground, I removed the gondola and put in moored boats on the right.

If you squint at this photograph and you applied color in a certain way it could almost turn into Monet's "Impressions: Sunrise"!

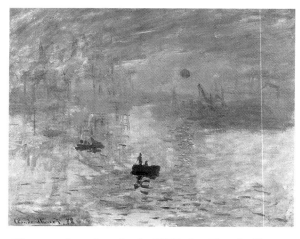

"Impression: Sunrise", 1872, by Claude Monet

"Morning Light, Venice, Italy" 8 x 10" (20 x 25cm)

Monet's approach to architecture

Monet said his aim was to convey architecture "without lines or contours", and to this end he avoided sharp contours and accents, building up the surface with thick, almost encrusted layers of colour. The result is that the eye is distracted from architectural detail, as the building appears to blend and melt into the atmosphere cloaking it — an illusion referred to as "Monet's envelope".

Monet was striving for the overall impression, and the sense of light and time of day.

Changing a scene to suit yourself

*B*ecause I had always imagined the city to be full of light and color, I decided to modify this scene of one of the most spectacular sights Venice has to offer.

Rearranging the scene
Here, I am using the image that I cropped from the scene on the previous page.

Here's the scene in three dimensions
This little drawing shows you the foreground, middleground and background.

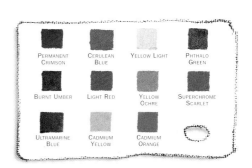

PERMANENT CRIMSON	CERULEAN BLUE	YELLOW LIGHT	PHTHALO GREEN
BURNT UMBER	LIGHT RED	YELLOW OCHRE	SUPERCHROME SCARLET
ULTRAMARINE BLUE	CADMIUM YELLOW	CADMIUM ORANGE	

Balancing the shapes
Because the architecture was quite intense I made quite a few preliminary tonal drawings. My challenge here was to get the balance working in the scene. The area I expected might cause problems were the domes, and they were going to be the painting's focal point. The secret was to reduce the complexity to shapes that "suggested" the architecture.

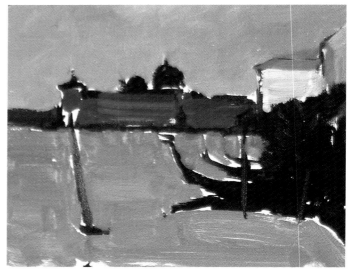

Linking the elements
I began building up the tones, finishing off the wash-in stage while aiming to tie the elements together to create balance and harmony. Although I am working in three distinct areas, if I don't link them together the result will be a painting that looks as if the three regions are pasted on.

background

Blocking in the lightest light
Because the buildings were to be the focal point they had to be the lightest — because light attracts the eye.

After blocking in the background this subject was well on the way. Notice the complete absence of detail. I simply put down my impressions of the scene.

Getting a sense of perspective
The building to the far right of this scene is a key element in establishing the perspective. The final effect was created by placing the gondolas in front of the buildings. The painting was taking shape.

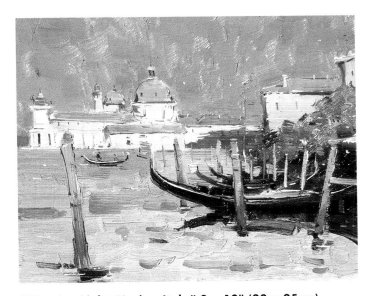

"Morning Light, Venice, Italy" 8 x 10" (20 x 25cm)
Notice the short, choppy brushstrokes in the foreground. Compare these with the smooth strokes for the background water. "Spikes" of complementary color add vibrance to this painting, and its sense of immediacy is enhanced by the exaggerated angles of the poles.

How the painting translated as tones

What would happen if we removed the foreground pole?
Our eye would travel right out of the picture.

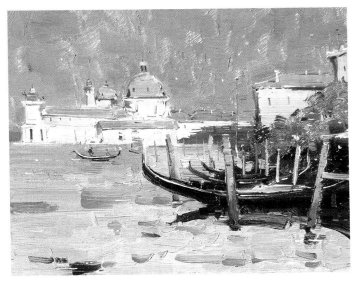

"Looking across the Grand Canal"
Another three-ground painting. The
architecture in Italy is truly amazing. The
buildings are a work of art in themselves
and present the artist with an enormous
challenge. The way to do it is to look for
the biggest shapes first and simplify the
composition.

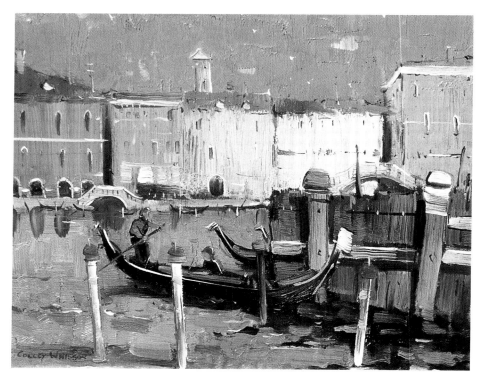

Friendly Advice

Look for the essence

The next time you are looking for
a scene to paint, the first thing to
identify is the essence of the subject.
It may be a rowboat, or an old house
with marvelous character, but you
can build a successful painting from
just one small spark of inspiration.

Tonal map
The values division reveals the foreground,
middle ground and background split. Here,
the foreground is defined by the whiteness
of the poles and those glorious spots of red
that attract the eye first, then the eye is led
by way of the structure supporting the walls
of the canal through the middleground to
the gondola, which has a highlight leading
the eye to the light-struck buildings lining
the Grand Canal. A pleasant journey for
the eye to follow.

Shape map
This is what our shape map reveals — many
elements reduced to simple shapes.

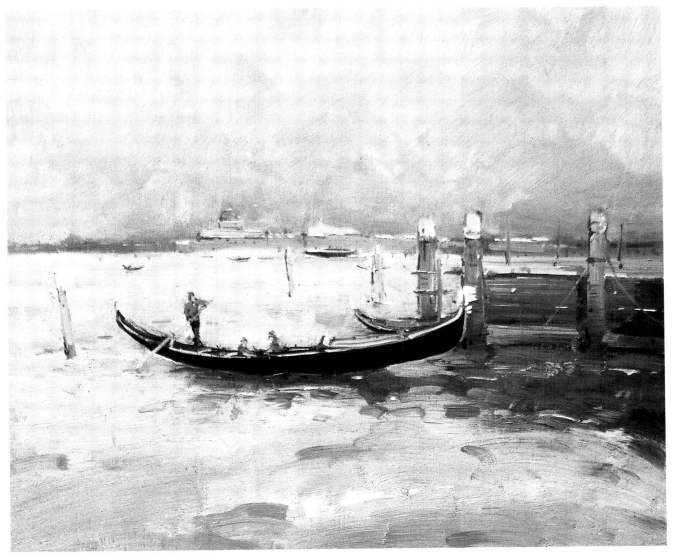

"Venetian Morning", 10 x 12" (25 x 31cm)
Here I used a different type of contrast to lead the eye to the
focal point, the gondola. Its black shape stands out against
the harmony of blues. Notice, though, how the color-infused
shadow links the gondola with the rest of the picture.

*Although I am working in three distinct areas, if I don't
link them the result will be a painting that looks as if the three
regions are stuck on.*

Painting the urban landscape

ave you considered the street as subject matter? Study these two versions of a well known Melbourne road, complete with famous tram running down the center of the street. Viewpoint and composition play major roles in the success of these two pieces. Notice the different treatment of the foreground areas. I also used complementary color to good advantage here — green offset by careful placement of spots of red; violet offset by yellow.

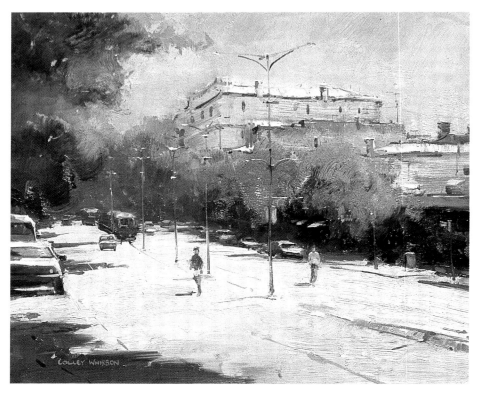

"St Kilda Street Scene"

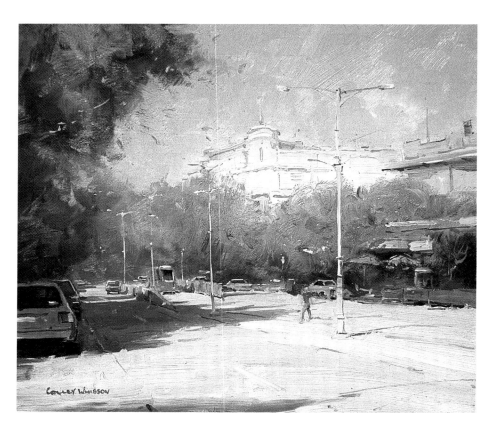

"St Kilda Street Scene II"

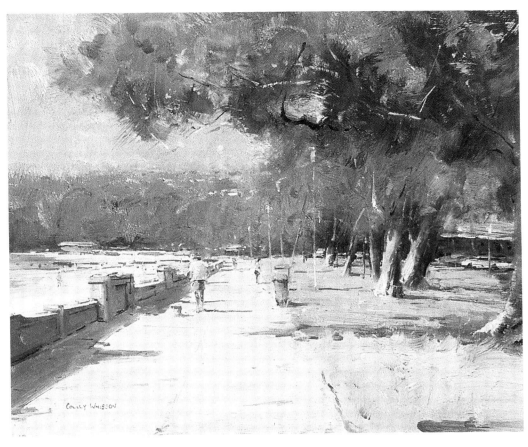

"The Yellow Shirt"
Here's another subject that many people might overlook. Notice
the use of perspective, viewpoint, tone and color in this scene.

Tonal map

**Foreground, middleground and
background areas**

Composition diagram

Suggesting atmospheric perspective

HERE'S WHERE WE DISCUSS THE MIRACLE OF HOW TO FIT A MAGNIFICENT VISTA ONTO A SMALL RECTANGLE OF CANVAS AND TO MAKE IT LOOK BELIEVABLE.

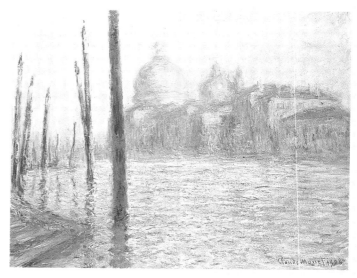

"Santa Maria della Salute and the Grand Canal, Venice", 1908, by Claude Monet

The words, "Paint what you love, love what you paint", spoken by great Australian artist, Tom Roberts, mean a great deal to me. They remind me that no matter what subject I choose, a certain amount of emotional input is required. My heart needs to be in it.

When it comes to the vista, I believe I am not alone when I say the landscape holds me in thrall. The Impressionists were fascinated by the effects of natural light on color. They took every opportunity to portray the fleeting interplay of light and shade, and the landscape is the perfect vehicle for such exploration.

In 1871, Monet immersed himself in painting the countryside. The river at Argenteuil, and his poppy-filled meadows, through which small groups stroll, became his signature for that period. His landscape paintings frequently included a figure, but the landscape was always dominant.

"This Time of the Day", 14 x 18" (36 x 46cm)
Every now and then I will revisit an area at a different time of day
or season, and the scene can look so different that I am inspired to
paint anew. Here, I placed the figures strategically with tones that
were clean and pure.

Creating the effect of distance

Atmosphere all the way

The illusion of distance is critical in a landscape, and it is achieved, as I said before, by painting mainly cool tones in the background and warmer tones in the foreground. The overall temperature of a painting is controlled by how you place the warm and cool tones.

Photo of the scene
This is Cremorne Point on beautiful Sydney Harbour. How I handled the rather intense sky and the huge foreground sea would be important. The background would play a major part in this picture. My goal was to turn this view into an impressionistic scene, full of color and light. Tone would be crucial in achieving the effect of aerial perspective. The painting's success depended on it.

If you squint your eyes this is what you'll see
Here's how the scene looks. There's plenty of work to be done here.

Distance is the thing

It is the impurities in the atmosphere that determine how we see an object. When you look at a distant mountain range, more often than not you are looking at it through a veil of air containing minute particles of dust or water droplets that block the light, making the mountains appear hazy.

These particles also affect the spectrum of light, filtering out some of the reds and allowing the blues in the spectrum to reach the eye. Therefore, the further away the mountains are, the bluer and paler they look.

The sky is the ultimate backdrop.

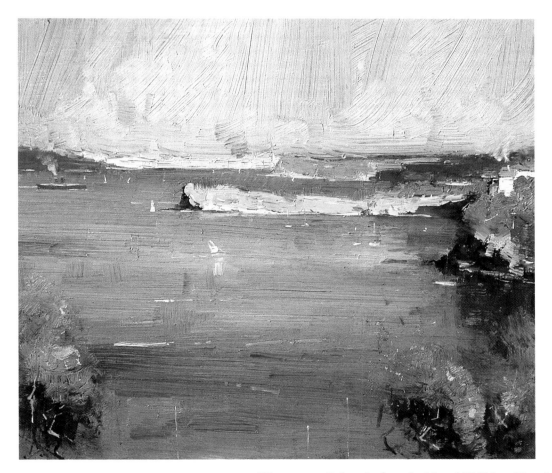

"Cremorne Point, Sydney", 14 x 16" (36 x 41cm)

As you can see from the scene photo, the sky was a strong blue which begged for Ultramarine Blue. The headlands in the middle distance were the focal point. The sky acts like a mirror reflecting down into the water.

My aim was to create a feeling of volume in the water. Placing the focal point fairly high — approximately one-third down from the top of the board — encourages the viewer to look into the scene. I was careful not to fill this picture with too many details, although I did include a few boats, yachts and a ferry, because Sydney Harbour is usually a hive of maritime activity.

See if you can pinpoint my use of warm and cool colors throughout this painting.

Subtle atmosphere and nuances of color

Giving my paintings a burst of color brings them to life, so long as all the colors and tones harmonize. I choose a subject that is lively in color and I avoid scenes that are flat in tone and color because they usually turn out a bit cold and insipid.

Searching for the major shapes
For the wash-in I used a mineral turpentine mixture as I searched for the major shapes of this subject. The middle distance shadows and the foreground shadows would be crucial.

Friendly Advice

Make use of every element you can

You can lead the eye with shapes, line, shadow, color and tone. Examine the paintings in this chapter to give you some ideas you can add to your painting repertoire.

Monet lay in wait for that passing cloud, that fleeting burst of sunlight, that moving shadow.

Establishing the ultimate backdrop
Once the wash-in was dry I began work on the sky, mixing Ultramarine Blue and Permanent Crimson with Titanium White. I consider the sky area the ultimate backdrop.

Setting the middle distance
The misty, cool colored mountain range was in place so I introduced the middle distance tones. Notice the pattern of light and dark shapes and how the light shapes lead the eye to the distance.

I made sure I kept some sky colour and I mixed this with the distant foliage tones to enhance the effect of color recession.

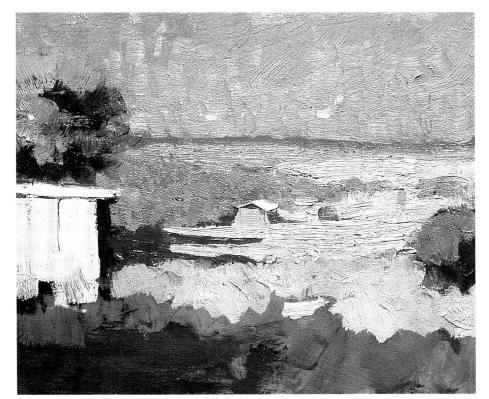

Paying attention to the foreground
Next, I cleaned up any loose ends in the middle distance and turned my attention to the foreground. Aerial perspective dictates applying the richest, warmest tones in this area. Introducing the shed in the foreground aided the persepective considerably, since it aligns with the smaller hayshed.

Bringing the painting to life

All paintings have crucial areas in which a carefully placed element can be used to bring the picture to life. The foreground shed was a major compositional device, which linked beautifully with the middleground hayshed, but something else was needed. I had a brainwave and added a drift of smoke suggesting a "burn-off" in the far distance. This linked the foreground and middleground with the background and boosted the effect of aerial perspective.

Just as important in this composition are the foreground shadows which draw the eye into the painting. The addition of a figure, including a bright blob of complementary color, attracts the eye quickly. The sapling in the right foreground serves to keep the eye in the central area.

Tonal map

Shape map

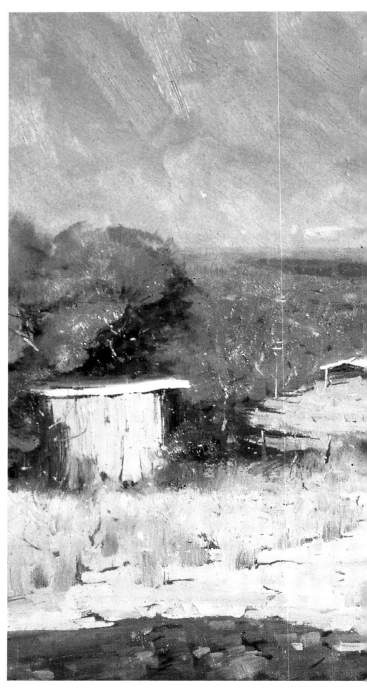

**"Summer Shadows Caress the Landscape, Victoria",
10 x 12" (25 x 31cm)**

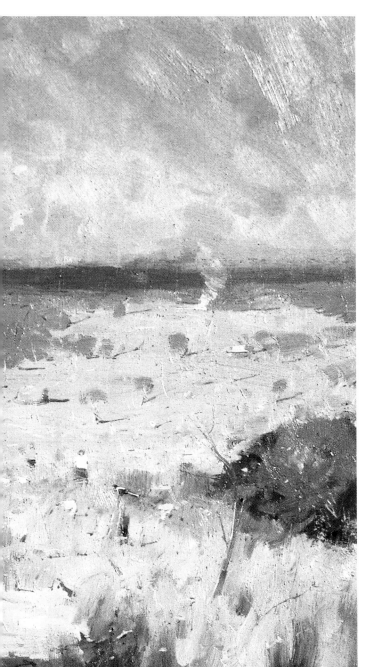

Every element is crucial
When you are designing a professional painting, every element plays its part. Look what happens when we delete the figure and the sapling.

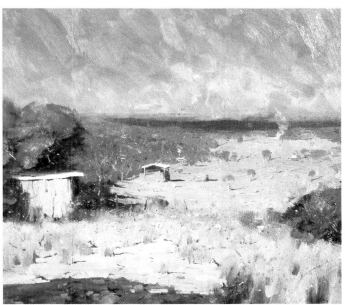

Detail

Detail

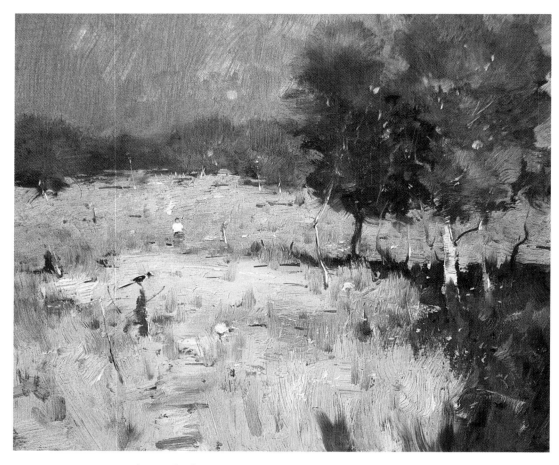

"Enchanted Afternoon, Queensland", 8 x 10" (20 x 25cm)
The shadow falling across the foreground is the crucial element in this scene.
It helps to set the agenda, giving this painting a strong feeling of sunlight.
I believe it is my job to make a scene exciting, whether by adding a figure, a fencepost
or a house. I add "something special" to bring the picture alive.
In terms of establishing distance, the shadows, the path, the tonal recession in the trees
all do their work. Notice how I used a touch of sky color to gray off the distant tones.

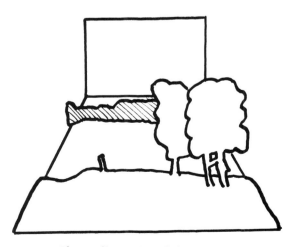

Three-dimensional diagram

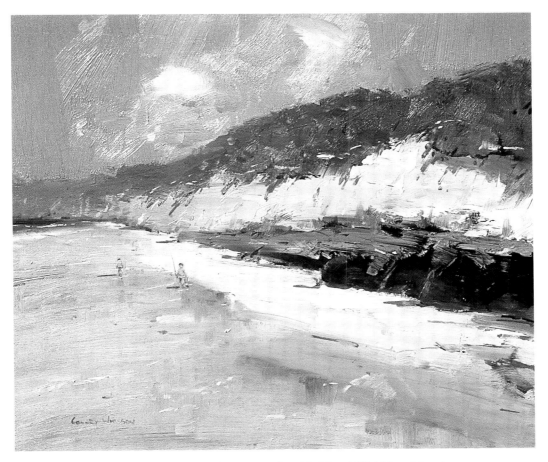

"Rainbow Beach, Queensland", 11 x 13" (28 x 33cm)
This stretch of coastline is quite spectacular. Achieving aerial perspective
was tricky here and the sandy region in particular required close attention.
While cool colors recede I was careful not to allow the sand to become too
cool or the painting would look flat and uninteresting.

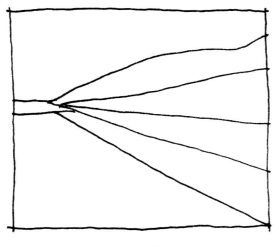

Composition diagram

"Summer in the Grampians, Victoria",
11 x 13" (28 x 33cm)
This composition is dominated by the creek that winds its way through the landscape. The s-shape controls the viewer's eye and leads it into the distance. The Grampian mountain range in the background plays an important part as a visual aid because the blue tone also serves to draw the viewer's eye through to the distance.

"Midday shadows, The Grampians, Victoria",
11 x 13" (28 x 33cm)
I believe that a successful painting is one where you control the viewer's eye so that it is led to settle on the focal point. Here the focal point is the shape in the foreground. The perspective of the fenceposts helps to lead the viewer's eye into the distance.

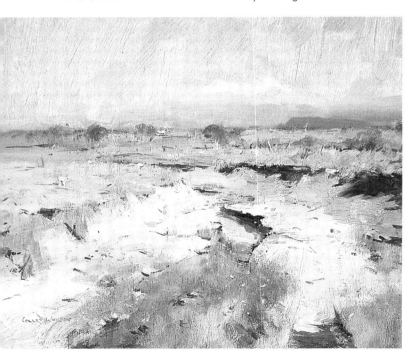

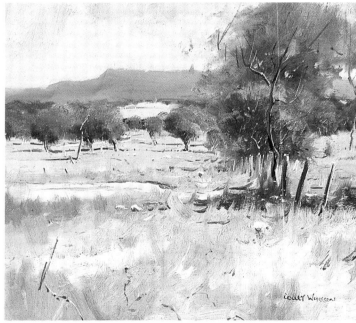

Composition diagram

Tonal map

"Coastal Vista, Sydney", 14 x 16" (36 x 41cm)
This picturesque view had the potential to become a "candy-box" image if I wasn't careful.
To combat this I decided that introducing some mood was essential. The foliage in the
foreground keeps the eye in the central region. The main focal point is the sunlit sandstone
on the cliff face. The reflection required careful color mixing. I had to be careful that this
dreamy interpretation did not result in a headland that looked as if it was floating in mid-air.

Three-dimensional diagram

Tonal map

Zooming-in on a scene

When you are on site it is easy to become overwhelmed by the scale of the subject matter in front of you. A good technique is to practice zooming-in on just a part of the scene — that way you will not have too many elements to deal with, and very often the result will be a powerful painting.

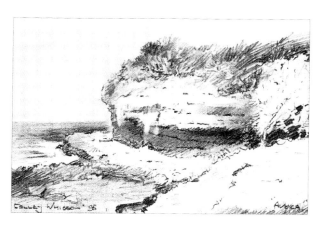

Working directly from a sketch
Most of my best work has come through from the drawing first, then painting process. For this demonstration I worked directly from a sketch. I made a quick impression to get the correct tonal balance — and I had my plan.

Blocking in the major shapes
I established a concept of background, middle ground and foreground. I covered the blank board with a turps wash, just aiming to cover it and establish the shadow areas. Most wash-ins don't look too exciting, but as long as I had the essentials I was happy. I let the wash dry for about 15 minutes, until most of the shine was gone.

The Impressionist landscape is like a portrait — it reveals Nature's state of mind.

— Raymond Cogniat

Working on the crucial area

I began work on the sky, and the most crucial area, the rock face and foliage. The sky was mostly Titanium White, Ultramarine Blue, Permanent Crimson with a touch of Yellow Ochre. I worked into the foliage on the cliff face looking for the wonderful abstract shapes in the foliage. Even at this early stage I could feel the painting coming to life.

Evaluation stage

My aim was to get a feeling of light and depth so I stood at a distance for a quick assessment. The rock face section and its shadow needed the most attention. Then I turned my attention to the sandy area which was mostly Titanium White and Yellow Ochre with a touch of Superchrome Scarlet.

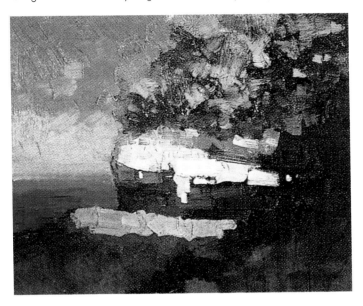

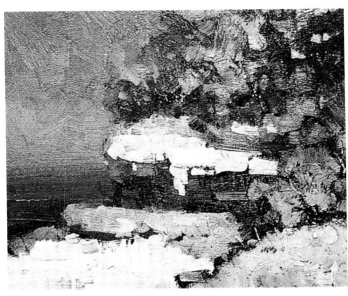

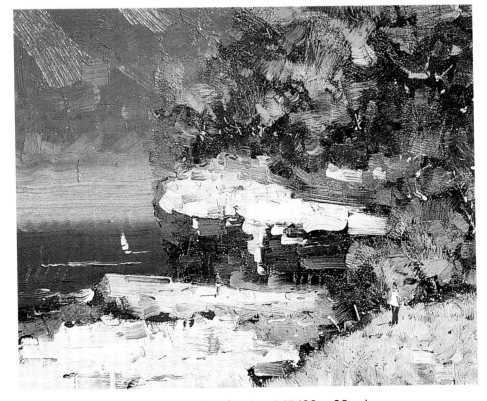

Finishing off

I made sure the foreground had the strongest shadows and the warmest tones. After a break of 30 minutes I came back with fresh eyes and made another assessment of the overall view. This is the stage where I place things like figures and boats, and this requires careful planning. I added the figures using a big brush in one or two strokes.

"Avoca Headland" 12 x 14" (30 x 35cm)

CHAPTER TEN

Using brushwork to

THE IMPRESSIONISTS ARRANGED THE WORLD INTO MYRIAD AREAS OF COLORED PATCHES USING THICK PAINT, DESCRIPTIVE BRUSHWORK AND NOTICEABLE PAINTING KNIFE PASSAGES.

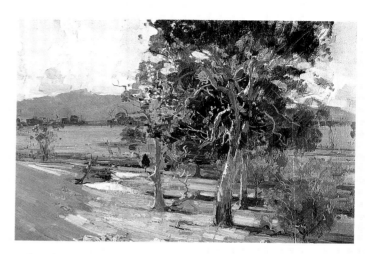

"The sheep country", 1920, by Arthur Streeton

One of the things that distinguishes an impressionistic work is the uniform loading of the paint surface, even in the shadows. Prior to the Impressionists, Academic convention dictated that the shadows should be painted thinly and transparently. However, the Impressionists preferred to paint more solidly, and brushed on thick, opaque paint in shadow and sunlit areas alike.

As well, instead of using linear drawing to define form or space, they used brushwork in an intentionally eloquent way — they varied the size, direction and shape of the brushwork to model their forms

Monet used strongly descriptive brushstrokes to describe the character of different objects. He used long, unbroken strokes, short horizontal daubs and abrupt jabs. His aim was to summarize the essential elements of the subject. His strokes were vigorous, and he used a flat brush that gave square marks.

Cézanne liked structure and volume, and he applied paint in thick patches using a painting knife.

Renoir, on the other hand, was famous for the feathery brushstrokes he used when painting people. They had a gentle, kindly, almost ethereal quality.

Some ideas we should pay attention to are the way the Impressionists use large strokes for the foreground and how they painted distances in small, almost imperceptible touches to enhance the appearance of recession. As well, small, jerky strokes separated foliage from the longer strokes of branches and tree trunks. Objects reflected on water were often described by vertical marks. Reflected light off the water was shown in contrasting long, horizontal dashes. Buildings were suggested using solid planes of paint that followed and stressed the form.

describe forms

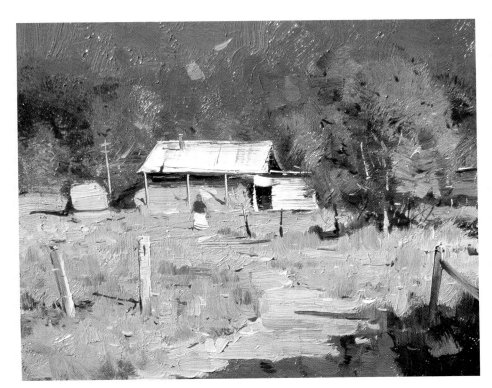

"Victorian farm"

Detail

Detail

Working with descriptive strokes

*F*or extra variety and broad effects you can also use a palette knife.

Blocking in the shapes
Using a thin turpentine wash I blocked in the major shapes, aiming to make sure I covered the white board. It is obvious, even at this early stage, that I have a tonal plan.

Thick paint and descriptive knife and brushstrokes
As you can see, there is plenty of variety in these strokes of thick paint. The sky was a blend of Ultramarine Blue, Alizarin Crimson and a touch of Yellow Ochre. The foliage area was dominated by Yellow Ochre with a small amount of Ultramarine Blue and a touch of Alizarin Crimson.

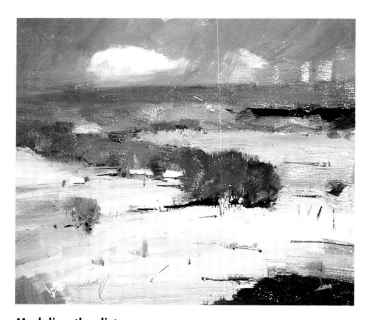

Modeling the distance
Everything was beginning to come into focus. I made the foliage tones warmer and darker in the shadow areas, enhancing the effect of distance. I darkened and lightened other tones until I had the tonal balance I wanted. A small figure completed the painting.

Finished painting

"A Chance Meeting – Italy", 11 x 13" (28 x 33cm)
The impressionistic painting style allows me to translate the initial impact of
a scene quickly. Very often a scene strikes me like a lightning bolt — the
finished painting flashes into my mind — and this technique allows me to
get my feelings down immediately.

Detail

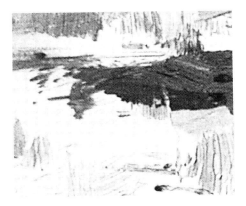

Detail

"Cool Water, Cremorne"
Of particular interest in this painting are the strokes used for the reflections. Notice how these strokes are mainly vertical.

Friendly Advice

Know your brush and its strokes

In the initial stages of a painting I use large ¾" (20mm) bristle brushes. Sticking to one size allows me to become familiar with the characteristics and limitations of the stroke. When the painting nears completion I may use a smaller brush. For delicate finishing touches, like fenceposts, shadows and highlights, I use a rigger.

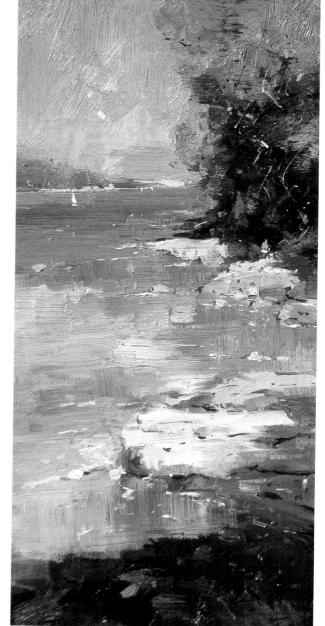

Detail

Detail

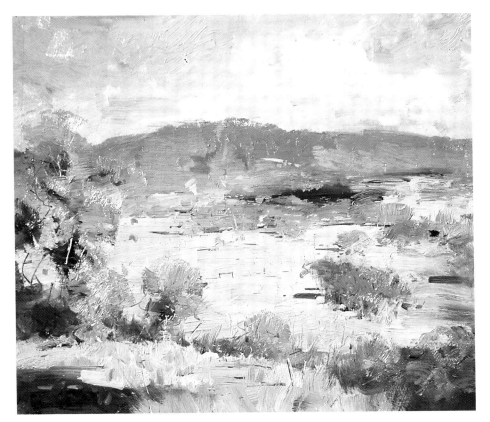

"Samford Valley Splendor, Queensland", 15 x 17" (38 x 43cm)
All the knife and brushstrokes in this scene are fluid and descriptive. To make this scene more dynamic, and to improve the tonal distance, I introduced a group of young trees to the left. Their strong verticals also served as a counterpoint for the many horizontals.

Develop a variety of brushstrokes

If an artist uses the same brushstrokes throughout the painting the finished result will be a monotonous work. The important point to think about is that a variety of brushstrokes gives you more options for solving problems.

Vary your strokes. Use vertical, horizontal and cross-hatch strokes. The key to an interesting painting is to use a combination of all these strokes.

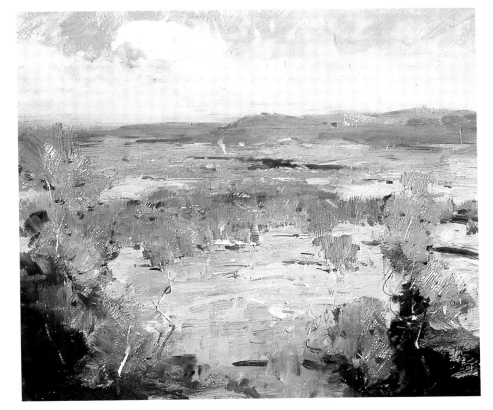

"Tenterfield Vista, New South Wales", 14 x 16" (36 x 41cm)
Here I used descriptive brushstrokes and maintained the basic rules of foreground, middle ground and distance.

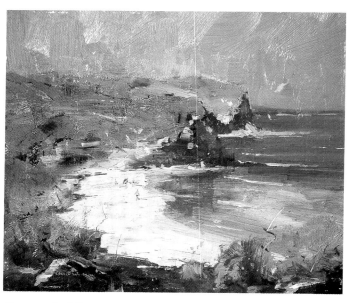

"Rugged Cliffs, New South Wales",
11 x 13" (28 x 33cm)
Because the cliffs are the focal point I varied the paint treatment in that area by experimenting with a combination of painting knife and brushstrokes. I wanted to create as much visual excitement as possible. A few improvements were made to the composition to improve the middle distance and foreground.

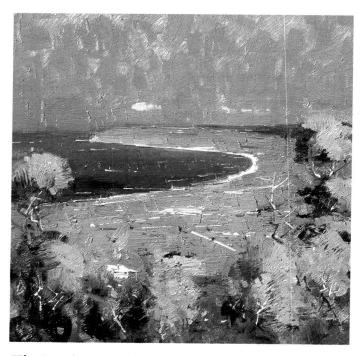

"The Mornington Peninsula", 10 x 10" (25 x 25cm)

Detail

Detail

Detail

Detail

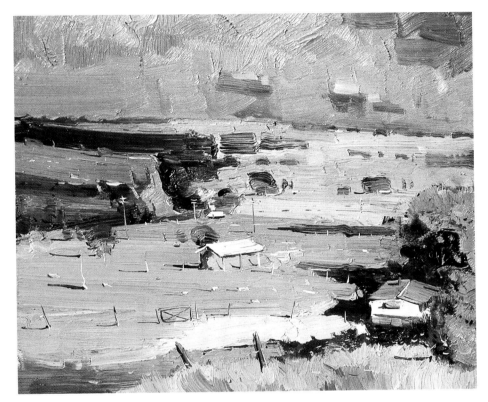

"In the Murray River Region", 12 x 14" (31 x 36cm)

Detail

Detail

I like to work the paint almost like clay, as if I am modeling the object. My idea is that the closer you come to the painting the more the brushwork and modeling become obvious, and this gives another dimension to the painting.

Figures add life and color

A dding a figure to a scene gives you the opportunity to solve composition and color problems. Figures liven up an area of foliage, they suggest mood, they serve as focal points and they give you the chance to add spots of complementary color and brilliant highlights. Figures suggest a story. As I said elsewhere in this book, they can be used to give a sense of drama, mystery or to transport us back to our carefree days of childhood.

Whenever you need something to add a little extra to your painting — consider introducing a figure.

"Potting Plants"

"A Big Thirst"

Figures should be simple shapes with little detail

The important thing is to ensure your figures blend in to the rest of the painting, instead of looking glued on

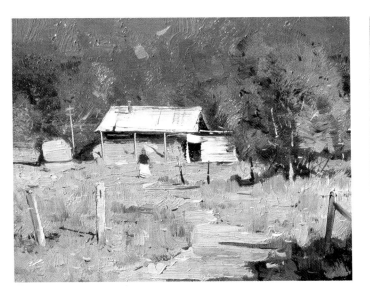

"Victorian farm"

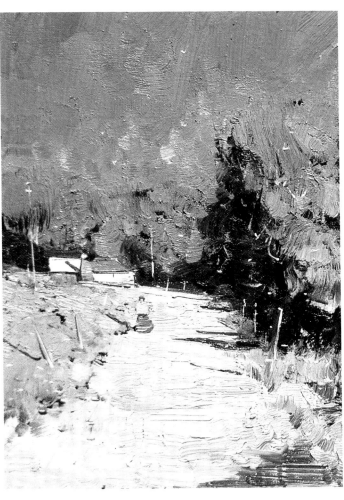

"A Long Stroll Home"
Here the brushstrokes for the figure echo the brushstrokes in the path, helping merge this figure with the painting. As I said before, the one thing you should avoid is making the figure look as if it is just "stuck on".

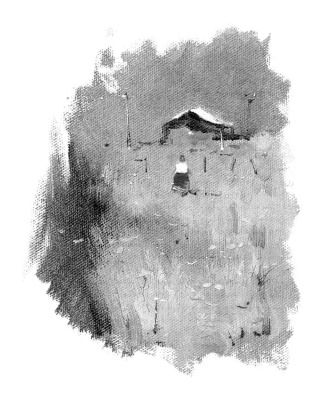

Use figures as a composition strategy
See how the red lifts this sunny meadow and gives the eye a resting place on its way to the distance.

Including a figure in your scene — An exercise

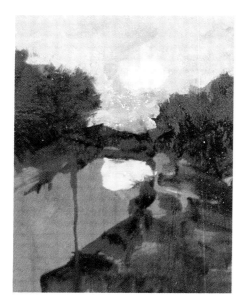

Forward planning
This will be a simple subject — a dirt track providing a wonderful light effect, but the figure will be the main focal point. This is a good example of what I mean by planning first, because we will not be dropping the figure in until much later.

First, I washed in the big areas, paying no attention to detail. The aim was to get the structure working. Notice how my thin underwash dribbled down the canvas. This was not a problem because it would be covered up later.

Establishing the darks and lights
I used the track to direct the viewer's eye to the focal point so my pattern of shapes and tones had to support this idea.

Working with the brush
I set the sky, middle ground trees, grassed areas and the track — all of which gave me an excellent opportunity to create texture and depth with my brush. This is part of the joy of working with oils.

"Spring Flowers, Italy",
10 x 12" (25 x 31cm)

in planning first

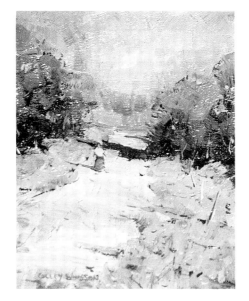

Adding a figure to a scene gives you the opportunity to solve composition and color problems.

Finishing off with the figure

Then it was time for the best bit. I placed the figure boldly, merely suggesting its presence with strong color. Once she was in I made refining statements all over the picture, dropping in some warm tones and highlights on the sky, foliage, track and grass. And of course, I planted some wildflowers.

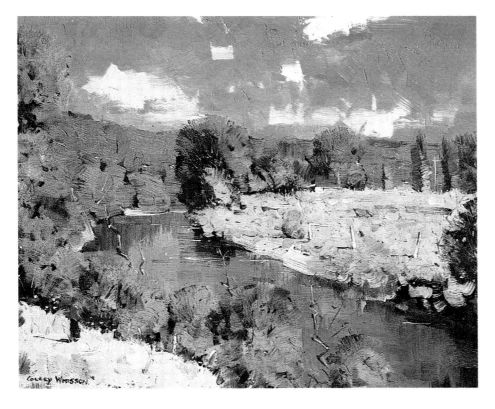

"Peaceful Water, Bald Hills, Queensland", 13 x 15" (33 x 38cm)

"Midday at Maroubra", 8 x 10" (20 x 25cm)

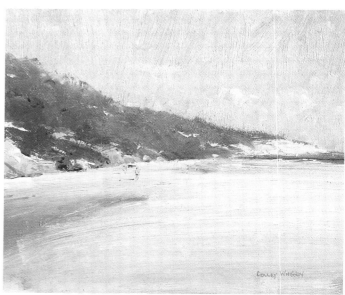

"Low tide, Rainbow Beach", 8 x 10" (20 x 25cm)

Don't forget, figures suggest a story, they can be used to give a sense of drama, of mystery or they can transport us back to our carefree days of childhood.

"Whisper of a Running Stream", 12 x 13" (30 x 33cm)

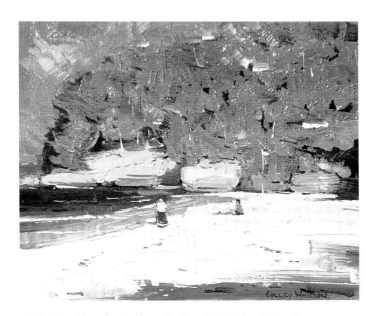

"Whiting Beach, Sydney", 8 x 10" (20 x 25cm)

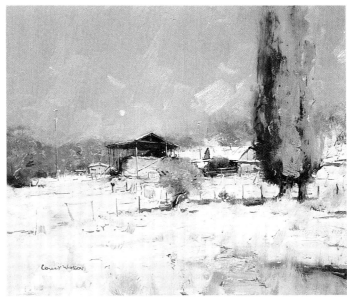

"Summer's Light, Castlemaine", 12 x 14" (31 x 36cm)

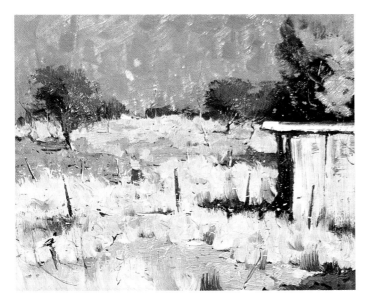

"Morning walk", 8 x 10" (20 x 25cm)

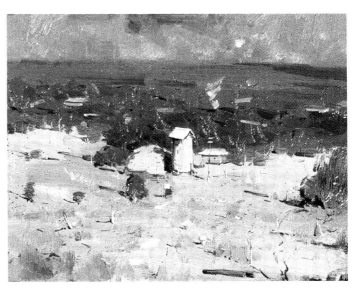

"Summer's Golden Glow, Ouyen", 12 x 14" (31 x 36cm)

SUMMARY

The last pieces of friendly advice

Almost from the moment I began painting my aim has been to produce more than just a likeable image. I want each painting to have a particular quality that will make it stand out from the crowd.

I believe that a painting requires strong tonal difference. It should have bold use of color. The compositional elements should be placed accurately so that the elements in the painting are balanced and the painting has a sense of natural grace.

I strive for a solution that makes the painting look simple and spontaneous. Hopefully the painting will go straight to the point.

When I first began painting my father gave me some of the best advice about composition — he told me to avoid placing shapes the same distance apart. He said the best tactic was to place big shapes against small shapes; that it was best to avoid having the edges of shapes touching, and to make sure I didn't compose the elements in such a way that I cut the painting in two.

I believe a painting does not need to be too detailed to tell the entire story. I will only add something extra if it is absolutely necessary. For example, if I am painting a scene from the Grampians in Victoria, I would like it to be true to the scene.

When I simplify a scene I make sure the tones are precise, or the painting will fall apart.

Some more friendly advice I would like to give is to resist the temptation to keep adding more details to the painting because the initial idea will go so far off track that the painting becomes irretrievable.

I believe the secret to making lasting images is in the quality of the composition. The concept of keeping the composition simple requires the major shapes to balance and blend together, or the focal point will not compel the viewer's eye. The placement of the elements in the picture is the crucial concept. I hope that the finished image speaks louder than words.

One last piece of friendly advice — try not to force your will onto your work — stay relaxed, and it will flow.

I hope that you will enjoy creating impressionistic paintings for many years, and that this book has helped you on your path.

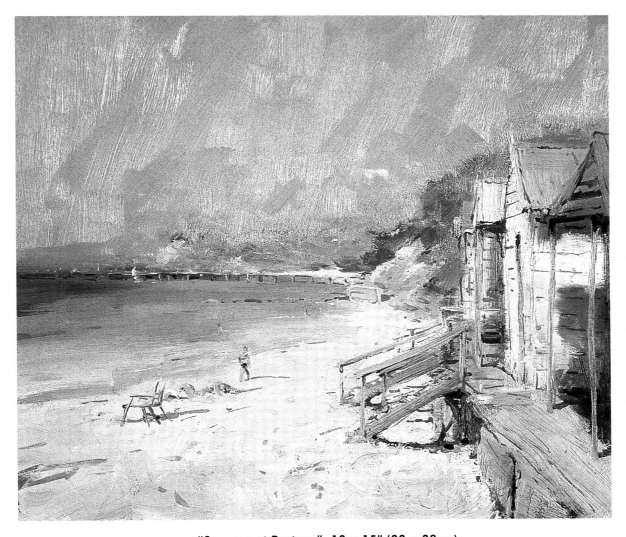

"Summer at Portsea", 13 x 15" (33 x 38cm)
I enjoyed the challenge of composing this scene — the combination of
the beach and man-made structures. The deckchairs and figures on the
left are extremely important because they help balance the composition.
I aimed to paint the boat houses with an impressionistic appearance,
not too much detail, but big on light effect. The foreground seagulls
play an important role because they help "stretch" the tonal range.

Gallery

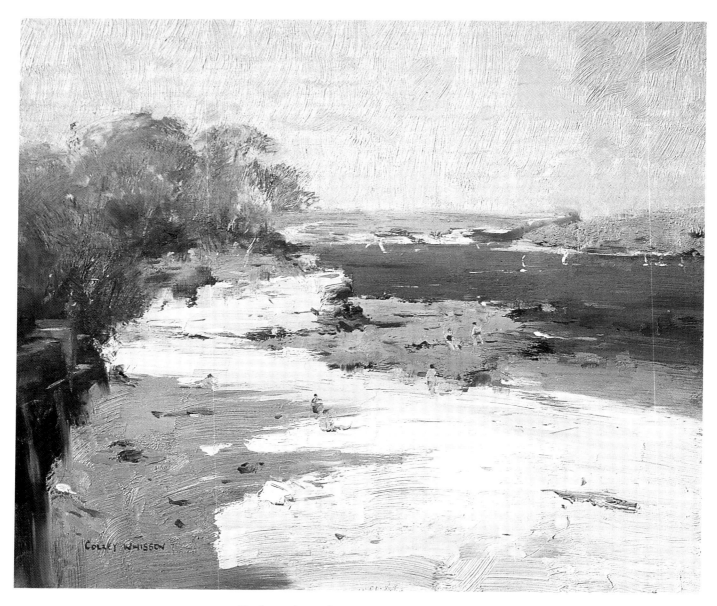

"Balmoral Beach", 12 x 14" (31 x 36cm)
The overall effect of the sunlight was the inspiration for this
painting. The tonal relationship between the shadow on the beach
and the sunlight required close attention. If the tones were not
correct, the painting would not work.

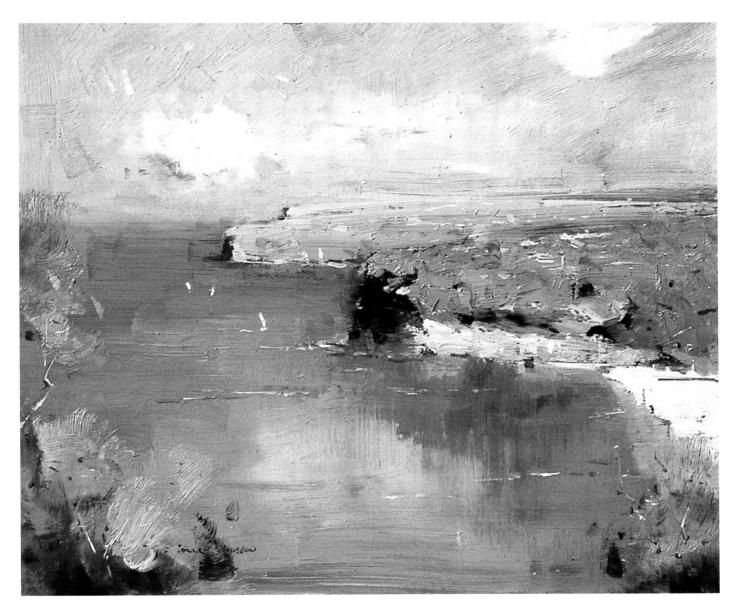

"Sydney Coastline", 10 x 12" (25 x 31cm)
Certain subjects require the painter to take a few more risks. This is
a relatively simple composition, so I needed to work harder to make
it come to life. The headlands are the focal point so my aim was to
concentrate on the tonal control in this area. It was crucial to get the
reflection in the water of the nearest headland correct, otherwise it
would look as if it was floating in mid-air.

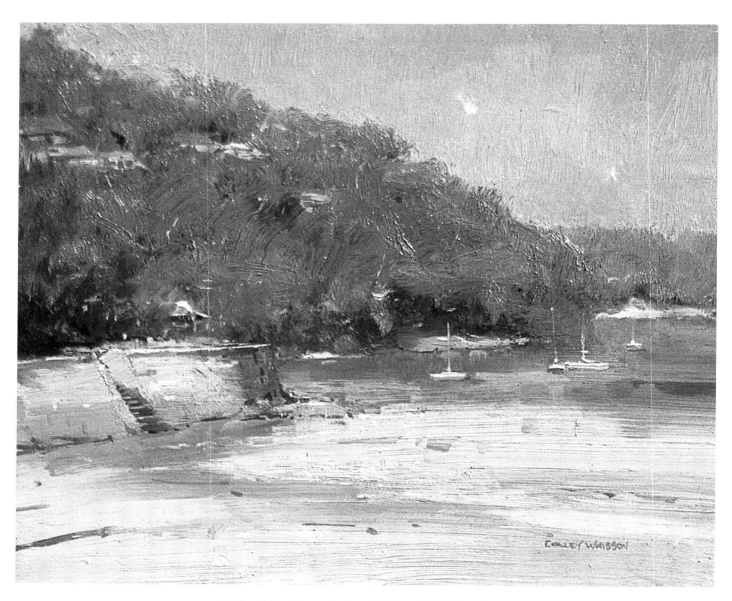

"Little Sirius Cove, Sydney", 11 x 13" (28 x 33cm)
I have been visiting this area of Sydney for over a decade,
it is my favorite painting place on Sydney Harbour. With this
painting, the foliage area is the dominant feature, so I had
to pay special attention to my use of tones.

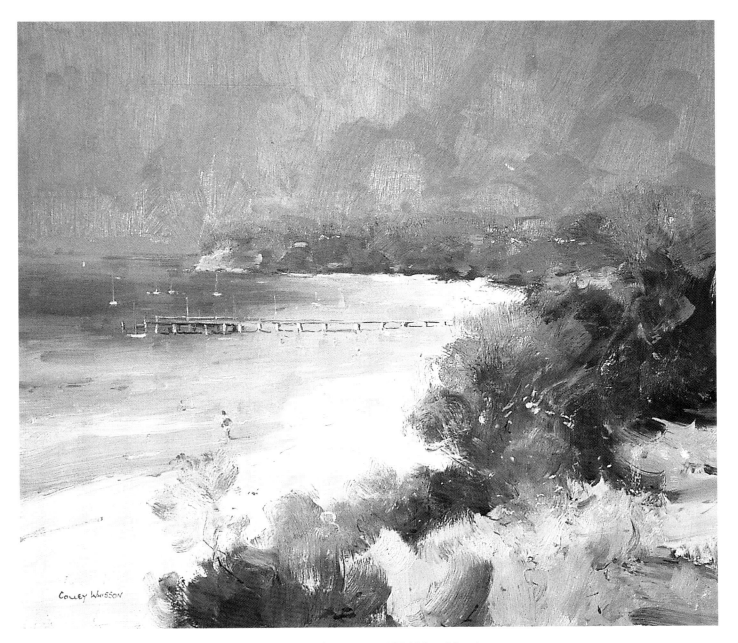

"Portsea Pier", 17 x 19" (43 x 48cm)

When I first saw this scene I was impressed by its clear cut regions — and my efforts were directed to tying the three regions together. The line where the wet and dry sand merge is important because it leads the eye into the scene. With the foreground bushes, I used my palette knife to build up texture and visual excitement.

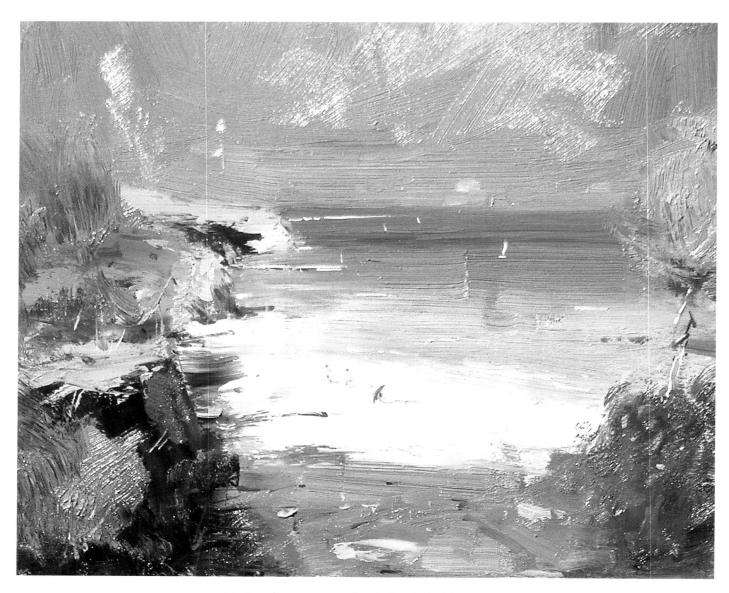

"A Morning to Remember", 8 x 10" (20 x 25cm)
This scene is close to my heart. My wife and I were staying with
good friends, and I was enchanted by the area — only two hours
from Melbourne. I dedicated some extra time to finding the best
vantage points. The scenery is naturally charming, and a little
planning certainly paid off in the end.

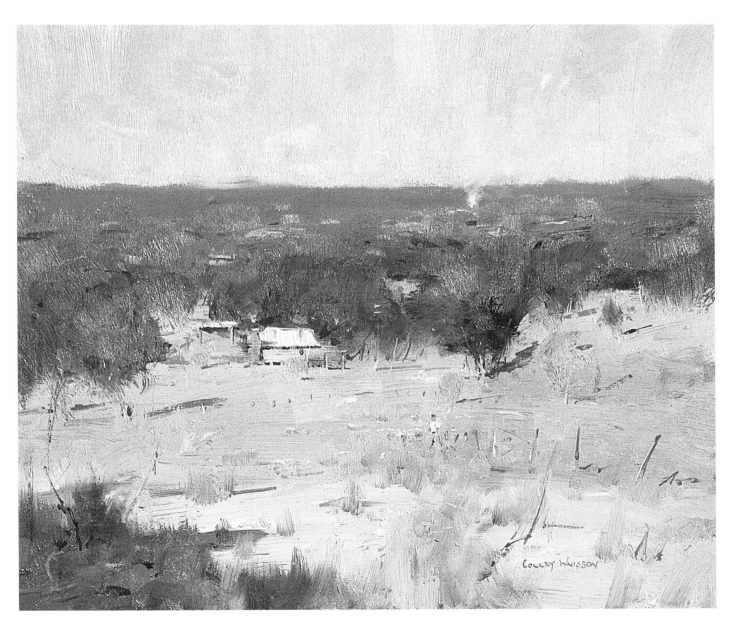

"Summer Excitement", 11 x 13" (28 x 33cm)
The buildings were my focal point, so I placed the darkest tones beside
the lightest lights. This keeps the viewer's eye in the central area. My
secondary focal point is the small figure in the foreground.

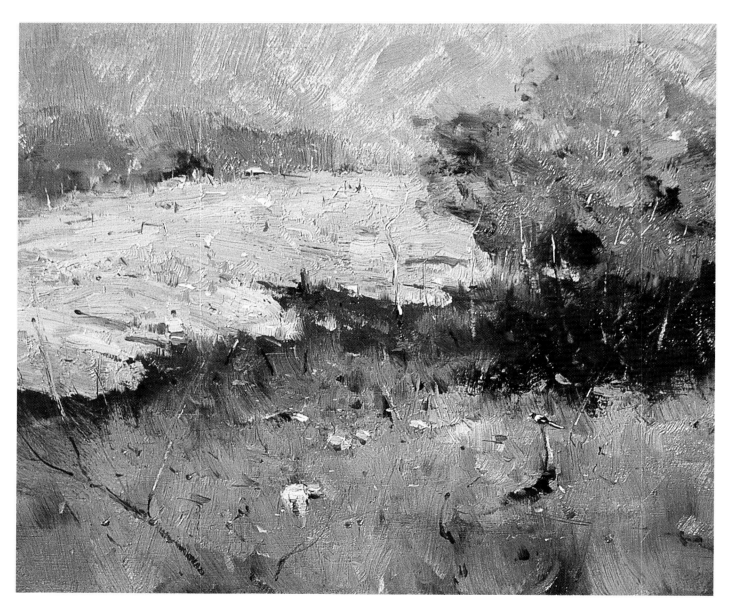

"The Last Rays of Light", 10 x 12" (25 x 31cm)
This scene is only five minutes walk from my home, so I am able to
view this in many different conditions. The first thing I did was to
determine the direction of the light. That is the story behind this
painting. The most difficult aspect was to achieve depth in the
shadow areas.

Who were they?

French, American and Australian Impressionists mentioned in this book

William Merritt Chase
1849-1916

Chase studied at the New York National Academy of Design and later moved to St Louis, where his work attracted sufficient interest that wealthy patrons sent him to Europe to study art.

When Chase saw the work of Manet in Paris it had a profound influence on his artistic taste and subsequent technique. He brought back impressionist work to America, and did everything he could to encourage its spread. He organised an exhibition of paintings for the National Academy of Design which included work by Manet and Monet.

William was elected a member of the National Academy of Design and taught at the Art Students' League and the Pennsylvania Academy of Fine Arts. He had two art schools named after him.

He was admired for his skill in capturing a sensation of intimacy and glowing light and for his dramatic and original compositions.

Chase visited Europe often. Eventually, he became leader of the "Group of Ten" painters, although not all artists in the group were Impressionists. His work was popular during his lifetime, but interest waned following his death, only to be rediscovered in 1981 when one of his pastels sold for US$902,000 at a New York auction. Seven years later the painting's value had doubled.

Charles-François Daubigny
1817-1878

Daubigny was born in Paris. He was one of the first artists to paint in the open air. His favorite subjects were paintings of quiet stretches of the Seine and the Oise rivers and he invested these scenes with all the flair of impressionistic atmosphere and execution. He painted in Holland, Spain and England as well as northern France. He visited England in 1866, and again during the war of 1870-71, when he helped Monet and Pissarro, who were stranded in temporary exile in London.

One of Daubigny's innovations was the boat he built so he could more easily paint on the French rivers. Monet followed his lead.

Childe Hassam
1859-1935

When Hassam returned to America after many years painting in France, he rented a studio on New York's Fifth Avenue, and joined "The Group of Ten" artists.

Well known for his 24 patriotic paintings of the American flag to mark America's entry into World War I, Childe imbued this works with all the tradition of the French Impressionists — especially Monet and Manet, whose colorful, bird's eye views of flag-decked windows had obviously inspired him when he painted his own series.

Claude Monet
1840-1926

Monet was the oldest son of a grocer. As a boy he gained a local reputation as a caricaturist but he was encouraged by artist Eugène Boudin to venture into landscape painting — in the open air.

In 1857 young Monet went to Paris and met Pissarro at the Swiss Academy, and a few years later met Sisley, Bazille and Renoir at the atelier Gleyre. He painted with these artists in the forests of Fontainebleau while developing his style. During the 1870 war Claude lived in London, Holland, Belgium and then returned to France where he spent six years at Argenteuil. Manet and Renoir worked with him on his floating studio on the banks of the Seine.

In 1890, Claude bought the house at Giverny where he built his famous water garden. Meanwhile he made many paintings on the Channel coast.

Monet enjoyed working in series — notably the Poplars and Haystacks, the Cathedrals, the Thames at London and finally the Water-lilies.

Although he did not contribute to three of the eight Impressionist exhibitions, Monet was the driving force of Impressionism.

Camille Pissarro
1830-1903

Pissarro was born on the island of St Thomas in the Antilles. A son of a Frenchman and a Creole mother, Camille was sent to school in France in 1842. He returned to work in his father's store and drew in his spare time. Later he was given a small allowance and permission to study art in Paris. In 1859 he met Monet at the Académie Suisse and he liked Monet's style.

His own Impressionist style of painting was well under way when the Germans invaded in 1870 and, unfortunately, all but 40 canvases from that period were destroyed. Pissarro was a stalwart member of the Impressionist movement but then extended his style to include the systematic division of color favored by Seurat, but this did not work out for him, and he returned to his earlier style. Later, he taught Cézanne and Gauguin.

Pierre Auguste Renoir
1841-1919

Renoir was born in Limoges, one of five sons of a struggling tailor. When the family moved to Paris, Pierre worked in a porcelain factory where he hand painted designs. He saved enough money to become a professional artist and entered the atelier of Gleyre in 1862 — the same year as Sisley. He made friends with Sisley, Bazille and Monet, often sharing Monet's studio when he was broke. He and Monet painted at Argenteuil and La Grènouillére at a time when the Impressionist style and philosophy was taking shape. He took part in the Impressionist exhibitions, and met success after his painting of Madame Charpentier and

her children was exhibited at the Salon in 1879. Suffering from arthritis, Renoir resorted to painting from a chair with a brush attached to his wrist.

Tom Roberts
1856-1931

Roberts and fellow Australian painters, Frederick McCubbin and Louis Abrahams returned from Europe full of ideas from the Impressionist movement. Almost immediately, they set up their first Artists Camp in Box Hill where, inspired by Monet's bird's eye view of Paris streets, Streeton painted Bourke Street Melbourne in the Impressionist manner.

It was Roberts who organized the "9 x 5 Impressions Exhibition" including work by McCubbin, Abrahams, Charles Conder and Arthur Streeton.

However, during his lifetime, Roberts earned no official honors, but his work has lived on. His paintings are held by all the major Australian art galleries. One of his most revered paintings, "Shearing the Rams", was done in the manner of a Courbet work, and it has become an Australian art icon.

Alfred Sisley
1839-1899

Although he was born in Paris, Alfred Sisley had English parents — his father was a businessman based in Paris. Alfred was sent to school in England when he was 18, ostensibly to prepare himself for commerce, but he turned to painting and joined the atelier of Gleyre in 1862. It was at this time he became acquainted with Monet, Renoir and Bazille. He worked with Monet and Renoir in the 1860s in the region of Fontainebleau and also along the banks of the Seine. His work was similar to Monet in its style and in his concept of the landscape. His work was included in the first Impressionist exhibition. After his father's business failed, Sisley fell into financial difficulties, and it was not until after his death that his work became recognized.

Sir Arthur Streeton
1867-1943

Streeton was one of Australia's greatest landscape painters. He was a pioneer of the outdoor painting method and in particular he displayed enormous skill in depicting distance, atmosphere, feeling and subject selection. His mighty vistas, with their vigorous, square brushstrokes, dominated the Australian art scene for more than a decade. He made frequent painting trips to London and produced a series of paintings from a visit to Venice. He was a war artist during World War I and finally settled in Australia in 1941. Arthur Streeton won a Gold Medal at the Paris Salon, and the 1908 Wynne Prize for Landscape in Sydney. He received his knighthood in 1937.

About the Artist

Colley Whisson was born in 1966 and has spent his life immersed in the art world, particularly enjoying drawing as a child. His main influence has been his father, respected Australian artist Eric Whisson, who was careful to nurture Colley's natural talent in a way that his own style would emerge.

Colley studied Figure Drawing at the Queensland College of Art, and Portraiture at the Brisbane Institute of Art.

Colley makes a point of including regular drawing sessions into his training.

Searching for a deeper understanding, Colley works outdoors as often as possible and undertakes outdoor painting trips in the tradition of the famous Heidelberg School of Australian artists.

Only six years after he began painting Colley began winning major prizes, and he has taken part in many mixed and solo exhibitions.

In 1996, he received his greatest personal honor to date when the Queensland Art Gallery asked him to hold a seminar called, "In Streeton's Footsteps", to help celebrate the Gallery's major retrospective exhibition of this important Australian Impressionist's work.

Colley continues to explore new subject matter and has received wide acclaim for his work. He has had several articles published in *Australian Artist* magazine; the *Courier-Mail* newspaper called him one of the top young investment artists in Australia, and he is sought after to take tutorials for art societies throughout Queensland.

He is currently represented in Australia by:

Pages' Fine Art Galleries
Beachside Gallery, Seahaven Resort,
9 Hastings Street, Noosa Heads, Queensland, 4567
Telephone: (07) 5474 5422

Red Hill Gallery
61 Musgrave Road, Red Hill, Brisbane,
Queensland, 4059
Telephone: (07) 3368 1442

McGrath Art Gallery
240 Miller Street, North Sydney,
New South Wales, 2570
Telephone: (02) 9955 6589

Kew Gallery
46 Cotham Road Kew, Melbourne, Victoria, 3101
Phone: (03) 9853 5181

Whitehill Gallery
RMB 3800 Mornington-Flinders Road,
Dromana, Red Hill, Melbourne, Victoria, 3937
Telephone: (03) 5989 2483

David Sumner Gallery
359 Greenhill Road, Toorak Gardens,
South Australia, 5065
Telephone: (08) 8332 7900

Boranup Gallery
RMB 329, Forest Grove, Western Australia, 6286
Telephone: (08) 9757 7585